CW00799012

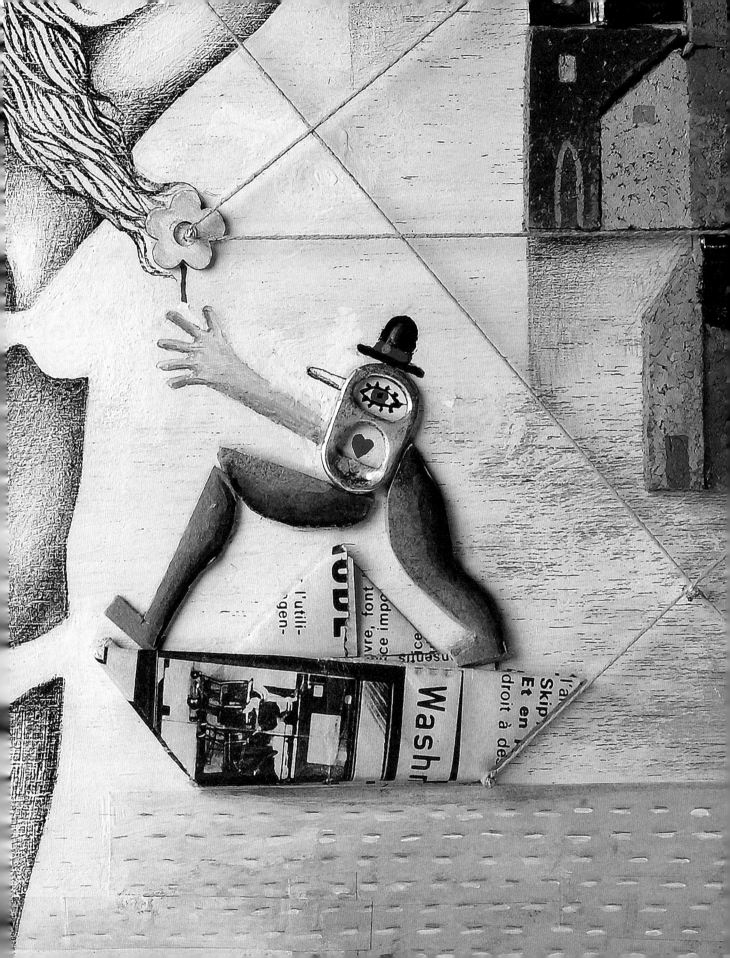

THE RESOURCEFUL ARTIST
Exploring Collage and Other
Mixed Media Techniques

© 2017 Promopress Editions
Texts and illustrations: Victor Escandell
Text and photos appendix: Alicia Martorell
Photos: Alicia Martorell, Victor Escandell
English translation: Kevin Krell
Graphic Design: spread: David Lorente
and Claudia Parra
Project coordination and copy-editing:
Montse Borràs
ISBN 978-84-16504-62-6

Promopress is a brand of:
Promotora de Prensa Internacional S.A.
C/ Ausiàs Marc 124
08013 Barcelona, Spain
Phone: +34 93 245 14 64
Fax: +34 93 265 48 83
email: info@promopress.es
www.promopresseditions.com
Facebook: Promopress Editions
Twitter: Promopress Editions @PromopressEd

With the support of

institut d'estudis
baleàrics
Balearic culture and arts

Printed in China.

THE RESOURCEFUL ARTIST

EXPLORING COLLAGE AND OTHER
MIXED MEDIA TECHNIQUES

Víctor Escandell

"All you can imagine is real"
PABLO PICASSO

promopress

TABLE OF CONTENTS

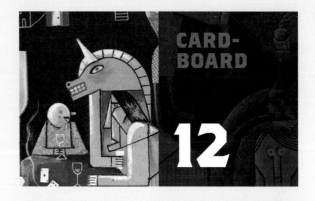

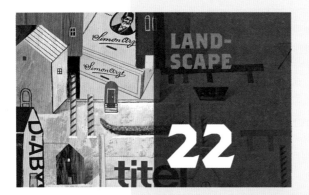

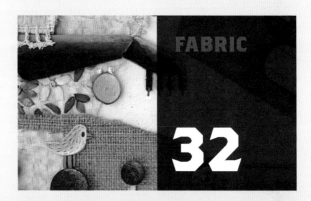

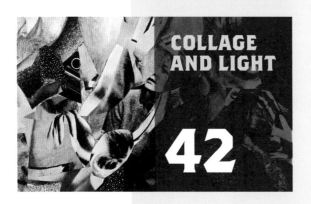

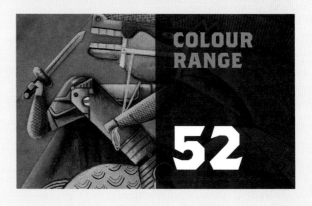

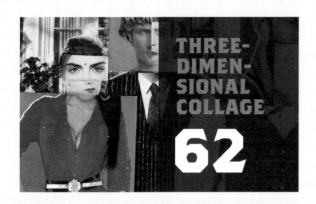
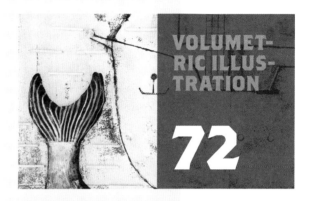
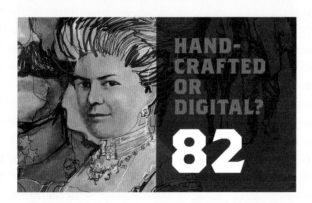

Anything goes!

TECHNIQUES, IDEAS AND SUGGESTIONS FOR EXPERIMENTING WITH DRAWING AND COLLAGE

VÍCTOR ESCANDELL

FOREWORD

One afternoon in Bologna, after an exhausting day at the book fair in this beautiful medieval city, the editor at Promopress proposed this book to me while peacefully enjoying a cold beer. "It would be nice if you wrote a book where you showed how you produce such special works", he said. At first, I didn't think it was such a great idea.

I frowned, timidly sipped my beer and didn't give a clear response. Yet, as you can see, he convinced me! And so here I am, writing the foreword to a book about multiple techniques based on my own illustrations, which always tend to have multiple styles. Phew! What a mess! To be honest, after finishing the book and assessing the entire process, I believe the result is worthy, beautiful and quite original. Or, at the very least, we had fun making it, and that's important too!

On the other hand, I'm not inclined to making speeches or providing elaborate explanations. My thing is drawing. For this reason, I tried to always cut to the chase and graphically explain certain considerations regarding my work process and some rather "generic" ideas regarding the field of illustration. I enclose the word "generic" in quotations because this book actually makes a conscious effort not to generalise. Our intention was not to be like other books specialising in step-by-step learning that approach different artistic techniques with rigor and educational intent. To the contrary, in the pages that follow, I attempt to explain my own creative process in a personal way without lecturing or, as I said, generalising. As we all know, "There's more than one way to skin a cat", and in the 10 chapters that make up this book, I will be explaining my secrets regarding how to do it. In the final section, Alicia Martorell, explains in a simple and accessible way how to build a small homemade photography set, an essential element if you want to reproduce your work with optimal results, especially if it has volume.

In each chapter, we'll explore a different technique and a specific theme, using the materials and tools necessary to achieve the results we seek in each case. In the practice exercises, we've also included some ideas and tips that have helped me throughout my professional career in the hope that they will prove useful to you as well.

More than handbook on how to learn specific techniques, my hope is that this book will serve as a source of encouragement and incentive, a tool for eliminating the prejudices that sometimes are associated with less conventional artistic mediums. I want to stimulate you to experiment, to immerse yourself in the deep ocean of artistic creation with freedom and without hesitation, mixing, investigating and enjoying the infinite universe provided by the interrelation of different materials and mediums. I don't know if I have achieved this or not. Still, I hope that during the journey that I'm proposing, you will enjoy, learn and make my motto your own: Anything goes!

Bologna

INTRODUCTION

SOME IDEAS THAT MAY BE USEFUL BEFORE GETTING STARTING

FORGET ABOUT TIME!

If possible, it's important to have a lot of time available. Forget about your cell phone, the clock, the new season for the latest television series, the losses of your favourite sports team, climate change... In other words, be ready to create without hurry or stress.

CONCENTRATE!

Free your mind of worries in order to fully take advantage of your creative skills. Concentrate 100% on the artistic process of your new work. This is essential.

A CLEAN AND TIDY WORKPLACE

Keep in mind that this type of technique involves the use a lot of materials and different mediums. In a very short time, your desk will be completely covered with all kinds of objects and tools. In order to ensure a good start, organize and prepare your desk for what's coming. Adequate light is also fundamental to being able to work efficiently.

ASSIGNMENT OR PERSONAL WORK?

When we're talking about a freely created illustration there are no barriers. All this changes, however, in the case of an assignment. As with all commissioned work, there is an issuer and a receiver, and, therefore, a commercial relationship. This is when "limitations" or factors to consider appear. These can include the type of client, the target audience for our artwork, the type of printing used to reproduce our illustration, the deadline given to complete the job, etc. These premises need not hinder or diminish the quality of the final result. Often, these externally imposed "limitations" heighten our self-expectations and strengthen our creative capacity.

THE IMPORTANCE OF THINKING: TWO DIFFERENT BUT COMPLEMENTARY WORK METHODS

– WORKING WITH YOUR MIND, consist of mentally creating your work before executing it, of previously planning the entire process that you will follow to carry out your illustration.
– WORKING WITHOUT ANY SET IDEAS, that is, creating your work while doing it, without evident goals, using intuition, spontaneity and chance. In this case, it's very important to "listen to the voice of your creation". While this may sound cheesy, the truth is it works! Pay attention to what occurs on the paper and in your mind. This is essential to predicting what our next step is going to be.

8

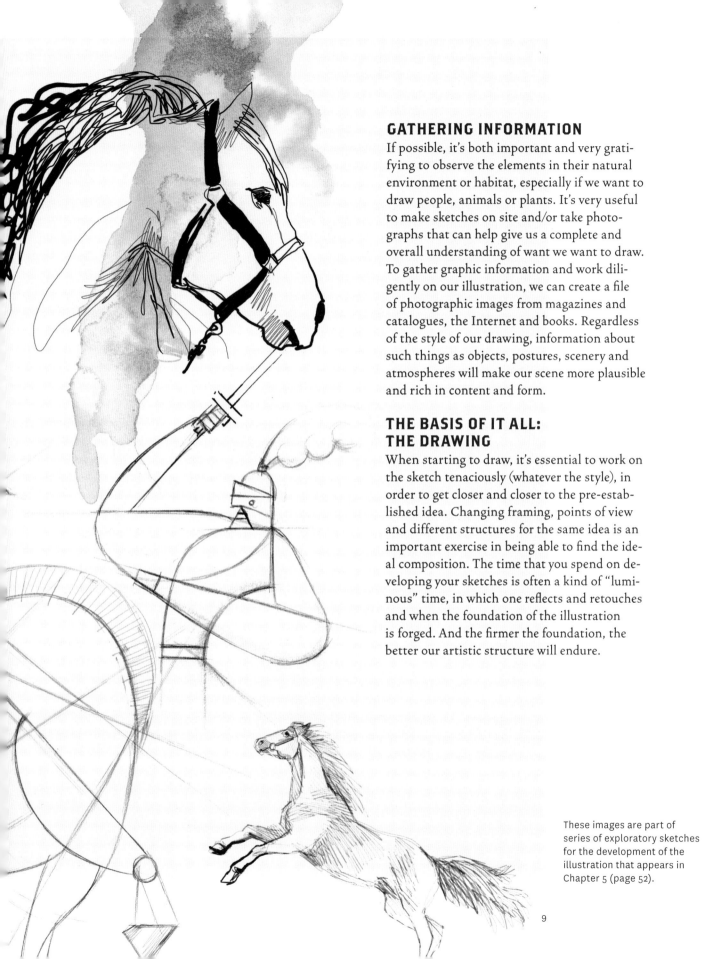

GATHERING INFORMATION

If possible, it's both important and very grati-
fying to observe the elements in their natural
environment or habitat, especially if we want to
draw people, animals or plants. It's very useful
to make sketches on site and/or take photo-
graphs that can help give us a complete and
overall understanding of want we want to draw.
To gather graphic information and work dili-
gently on our illustration, we can create a file
of photographic images from magazines and
catalogues, the Internet and books. Regardless
of the style of our drawing, information about
such things as objects, postures, scenery and
atmospheres will make our scene more plausible
and rich in content and form.

THE BASIS OF IT ALL:
THE DRAWING

When starting to draw, it's essential to work on
the sketch tenaciously (whatever the style), in
order to get closer and closer to the pre-estab-
lished idea. Changing framing, points of view
and different structures for the same idea is an
important exercise in being able to find the ide-
al composition. The time that you spend on de-
veloping your sketches is often a kind of "lumi-
nous" time, in which one reflects and retouches
and when the foundation of the illustration
is forged. And the firmer the foundation, the
better our artistic structure will endure.

These images are part of
series of exploratory sketches
for the development of the
illustration that appears in
Chapter 5 (page 52).

9

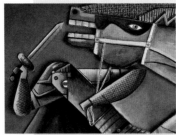
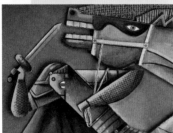
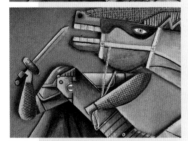
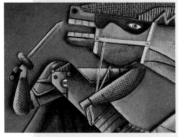

COLOUR

Words are not needed to express how important the treatment of colour is regarding composition in these four examples of one of the digitally retouched images that appears in the book. Observe how the same image changes, both formally and conceptually, depending on the colour range.

LET THE DRAWING SIT

Waiting a few days before deciding whether or not the original piece is complete is a method that, in my experience, has produced great results. The passage of time makes us objective observers. When one is immersed in the work process, we tend to miss the forest for the trees. If we let our work "sit" for a while, however, our self-criticism will be more constructive and precise. At this time, we can apply the finishing touches and consider the drawing complete. In any case, if we were unable to make all the changes we wanted to the original, it's important to note that, after the photo shoot and digitalization of the definitive image, we can always tweak our illustration to our liking with a image-editing programme.

AND NOW IT'S YOUR TURN. I HOPE WHILE EXPLORING THE CONTENTS OF THIS BOOK, YOU'LL DISCOVER NEW WAYS OF WORKING AND YOUR OWN WAY OF EXPRESSING YOUR IDEAS.

AND ALWAYS, REMEMBER: ANYTHING GOES!

READING GUIDE

Throughout these pages, you'll encounter ideas and tips that have helped me in my professional career and which we have structured in a highly visual manner:

A The text located on the side of the page, next to an exclamation point, indicates very specific information regarding the accompanying photography.

!

B A text surrounded by a frame of dots indicates a trick, tip or idea that may be useful for the creative process in general.

C Set between this graphic style located on the side of the page you'll find notes about art and artists related to the technique explored in the chapter.

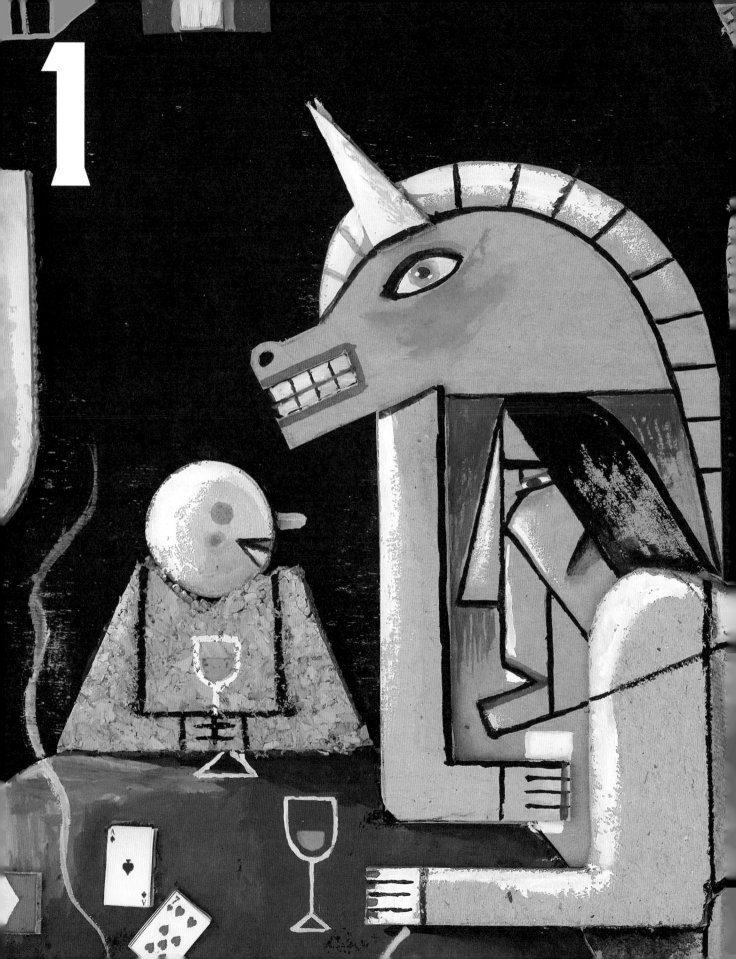

In this chapter we are going to explore the possibilities of cardboard, one of the most common and easily worked with materials.

Cardboard

The VERSATILITY of the EVERYDAY

Cardboard is an extremely versatile, porous and absorbent material that allows for a multitude of finishes. Mixing different thicknesses, types and tones (in addition to our pictorial contributions) will provide us with multiple possibilities when it comes time to make the illustration. At the same time, we'll give full rein to our imagination, lose our fear and become more adept at incorporating into our compositions the new materials and techniques that we are going to explore in the following chapters.

MATERIALS

OBJECTIVE
To make an illustration with cut outs and painted cardboard.

MATERIALS AND MEDIUMS

Wood
Cardboard
Corrugated cardboard
Red poster board
Beige poster board
Cork
Fabric paper
Wooden sticks
Round pieces of wood
Gouache
Metal rivets
Carbon paper
Tracing paper
Photos for collage

TOOLS

Metal ruler
Cutting mat
HB pencil
Cutting blade
Scalpel
Tweezers
No. 1 and No. 2 brush
File
Flat brush
Plastic palette
White glue

15

STEP BY STEP

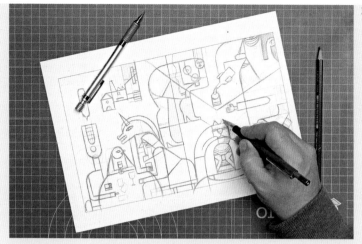

BEFORE GETTING STARTED

The first four points in this chapter can be applied to almost all of the chapters. If you make use of this practical and simple system, you'll find that is useful for your new creations and you will be able to efficiently apply all the techniques contained in this book.

DIAGRAM

A

Photocopy of the drawing on tracing paper to cut out the pieces

Photocopy of the drawing on tracing paper to use as guide

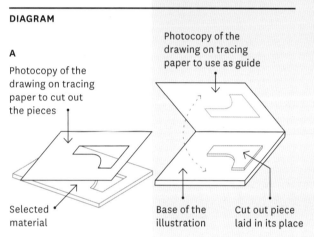

Selected material

Base of the illustration

Cut out piece laid in its place

B

Proportional scale based on the diagonal of the original

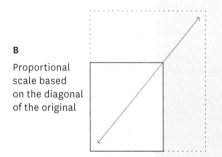

[**1**] First, we make a pencil sketch of the idea and composition, keeping in mind the actual measurements of the final format. You don't have to work with the actual size, but you do need to take proportion into account. A good method is to scale the image by using the rule of three or the diagonal.

[**2**] When the drawing is ready, we make two photocopies of the pencil sketch on tracing paper at the actual size. Using carbon paper and tracing paper, we now transfer the pieces of the sketch onto the different materials; later we'll cut them to obtain the final piece that we will glue onto our illustration.

[**3**] Next we'll glue one of the photocopies onto the upper part of the original (in this case, the medium is a 2mm-thick piece of wood). It will serve as a useful guide for precisely following the drawing and general composition.

[**4**] The other photocopy will be used as a template for drawing and cutting out shapes on the selected mediums. In this case, these include cardboard, cork and fabric, among others. In this way, we'll have exact pieces for assembling the composition while always reserving the other piece of tracing paper as a guide.

We'll use carbon copy paper and tracing paper to transfer the pieces of the sketch onto the different materials. Later, we'll cut them to obtain the final piece that will be glued onto our illustration.

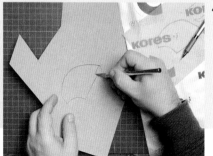

4

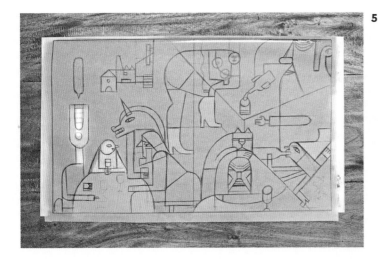

It is essential to be organized when gluing the pieces onto the medium. The trick is to arrange them in logical order. First, glue the background pieces and then the pieces in the foreground, making sure that the first ones do not cover the others.

[**5**] We now glue some pieces of coloured cardboard over the wooden base (in the example, in red) in a balanced manner across the entire surface.

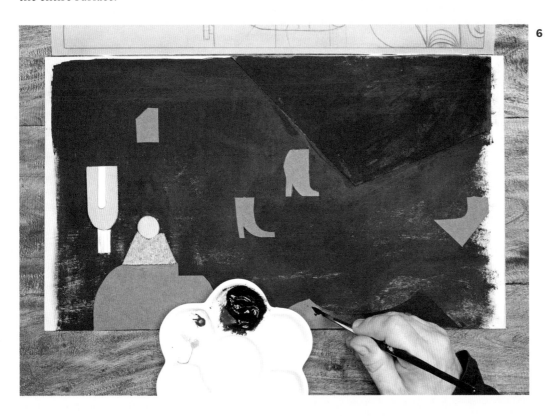

[**6**] Now we paint some of these pieces with black gouache using a flat brush (No. 8 or 10), taking care not to cover the background in a uniform and opaque manner but allowing the texture, quality, and colour of the wood and cardboard to show.

STEP BY STEP

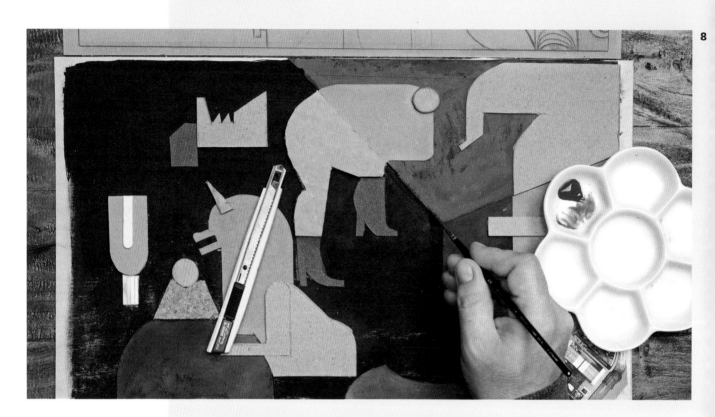

[**7**] Carefully, using the guide printed on tracing paper, we glue the pieces cut from the different materials we've selected (different types of cardboard, wood, cork, etc.) and situate them in their proper places to complete the ensemble.

[**8**] We will now paint these new pieces again without completely hiding the texture and allowing the previously applied black gouache paint to breathe. In this way, we'll achieve depth and expressive strength in the different textures.

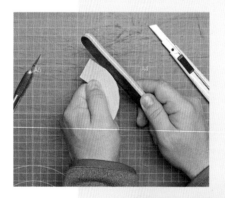

We can smooth down the rough edges and imperfections of the pieces with a file or a piece of fine-grain sandpaper.

We can use little round pieces of wood to make some of the characters' faces.

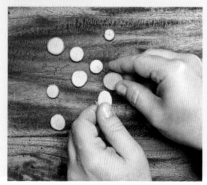

[**9**] In this next step, we'll outline and paint the different areas and materials with gouache, thereby giving shape to the drawing. Using a 0.5 pencil, a fine or medium tip marker or a round brush (No. 1 or No. 2), we go over the details and fine lines.

[**10**] We can add different types of material to the piece (fabric, metal nuts, etc.) to create visual contrast and enrich the illustration (for example, one of the characters' eyes). We then make the final touch ups and check the details and overall chromatic balance of the illustration to ensure that the piece as a whole is stable and harmonious. This will force the observer to direct their focus toward the areas that we wish to strengthen.

> A thorough review of the illustration as a whole will allow us to enhance the details we wish to touch up or improve. It will then be ready for the photo session and final scan.

You can also include actual, retouched photographs in the drawing (in the example, playing cards, the jukebox, etc.) acquired from image banks such as PhotoStock, Fotolia, Getty Images, Dreamstime or Shutterstock, to name just a few.

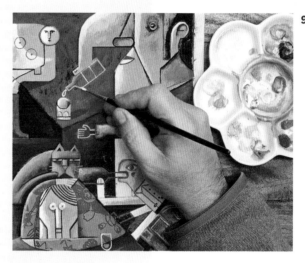

9

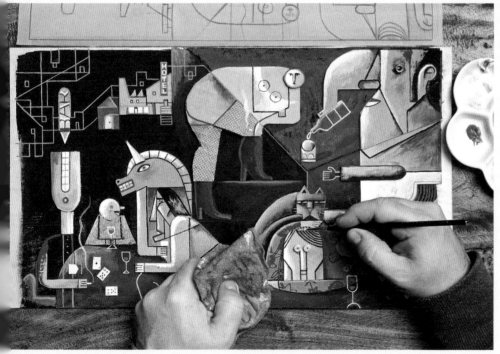

10

And now... Turn the page and see the finished illustration!

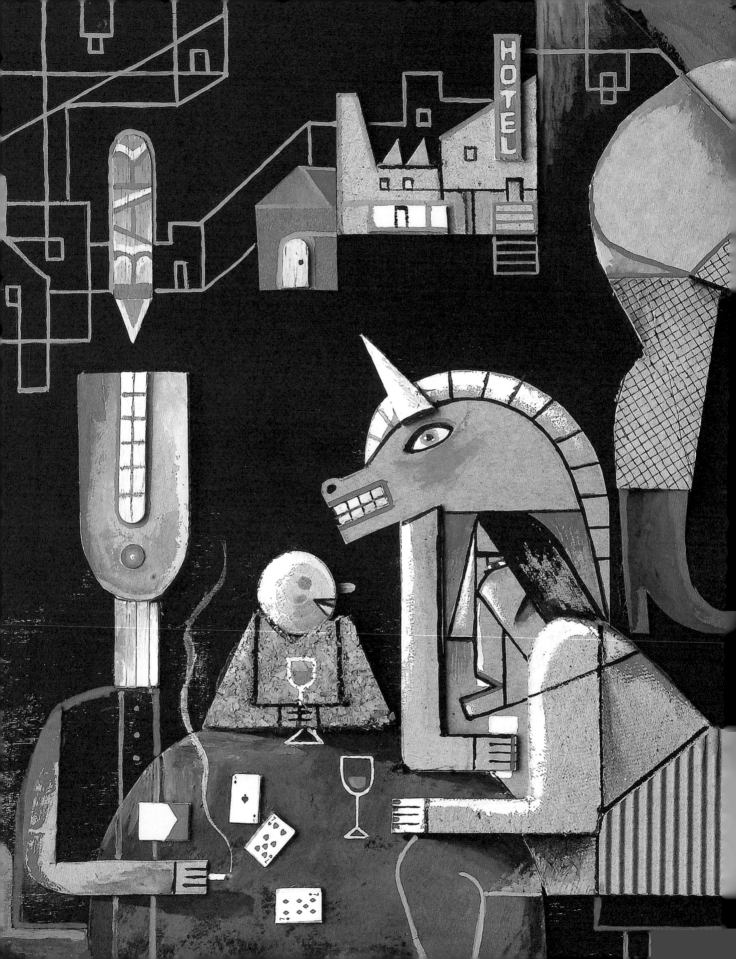

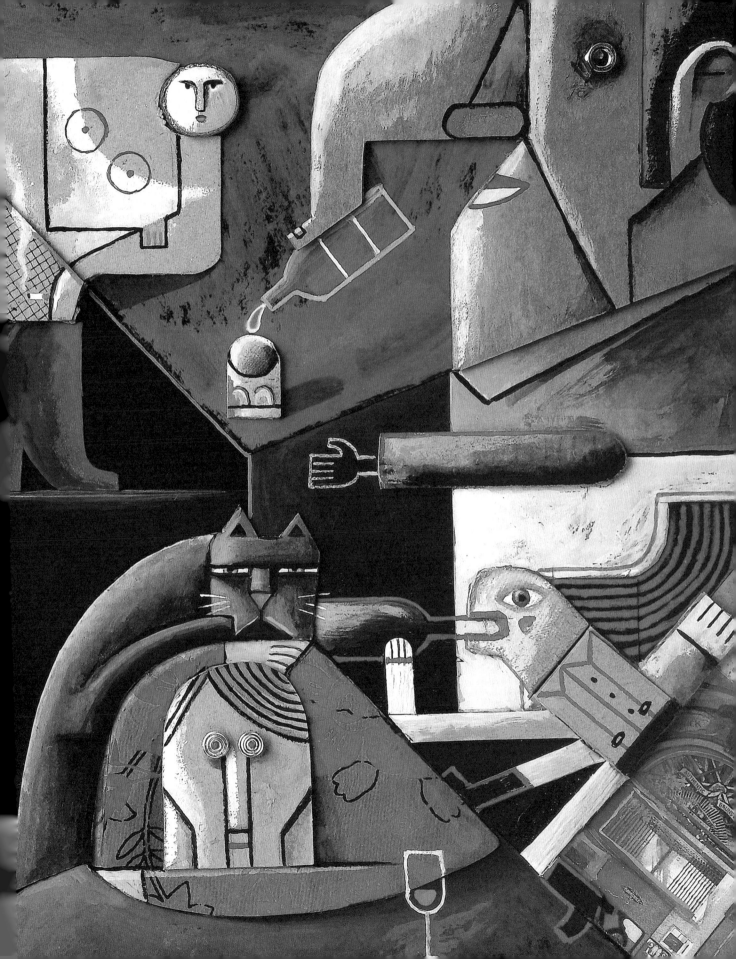

In this section we'll look at a new way to depict a particular scene (in this case, a panoramic view of a Venice canal) with a collage of magazine cutouts and other paper materials.

Landscape

COLLAGE as an ABSTRACTION TECHNIQUE

The drawing will always serve as the base of our composition and a large part of the style of our illustration will depend on it. However, it's the collage that we apply to the illustration that will help us not simply create a suggestive image but also discover the graphic formulas that provide a convincing balance of volumes and a perspective of our own, turning our scene into a landscape embodying a multifaceted, unique and original interpretation.

23

MATERIALS

OBJECTIVE
To create an illustration with magazine cutouts and other paper materials.

MATERIALS AND MEDIUMS

Cardboard
Magazines
Ochre poster board
Paper
Gouache
Wooden sticks
Liquid watercolours
Carbon paper
Tracing paper

TOOLS

Metal ruler
Cutting mat
2B pencil
Cutting blade
Scissors
0.5 marker
No. 1 or No. 2 brush
Thick brush for
 background
Plastic palette
Graphite fixative
White glue

STEP BY STEP

BEFORE GETTING STARTED

We're going to make a collage! Collect magazines and other materials to cut. Collage is an artistic technique that involves assembling diverse elements of different origin to achieve a new unified thing.

MAN RAY'S REVOLVING DOORS

Artist and photographer **Man Ray** experimented with collage as well. Between 1916 and 1917, he created his famous *Revolving Doors* series, which he presented in New York, consisting of a series of geometric shapes made from translucent paper that were framed and installed on a rotating pole that viewers were invited to spin. Man Ray described collages as pseudoscientific abstractions through which he depicted his interest in gesture and movement.

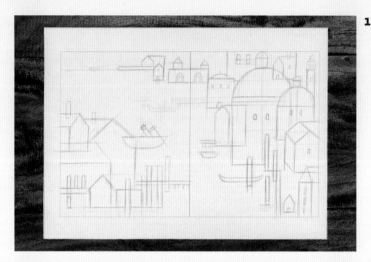

[**1**] After the pencil sketch is finished and defined, we'll make two copies on tracing paper in the actual size. In this case, and since tracing paper offers the possibility of seeing the drawing in two ways, we've decided to reverse the composition.

[**2**] Repeat steps 2, 3, and 4 of Chapter 1 (page 16).

[**3**] Now we'll cover the cardboard surface with white gouache using a wide brush, varying the pressure of the strokes for texture and depth. The result won't be a uniform surface but one of variable coverage and transparency.

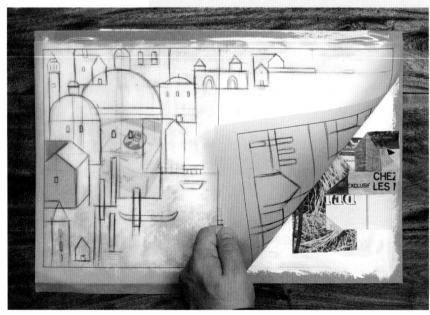

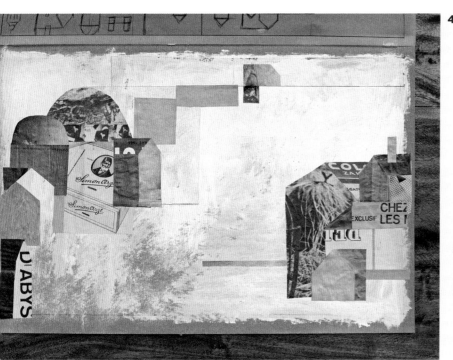

The uneven texture of the paint on paper will serve as an excellent base for the pencil that we'll use in the finishing phase.

[**4**] We'll then glue pieces of this same cardboard and paint them white (just like the background) to create different levels and subtle volumes that will create an outline solely by virtue of their unevenness and corresponding shade (e.g., the horizon).

[**5**] Using the photographic material we collected, we now cut the different pieces transferred from the sketch onto tracing paper.

5

Scissors work best for cutting round shapes. However, for straight lines you can use the cutting blade (always using a metal ruler) for a cleaner, more precise cut.

STEP BY STEP

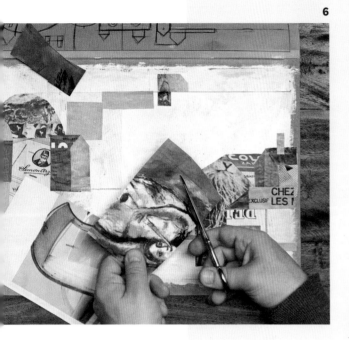

6

[**6**] We cut pages from different magazines to create the pieces, trying to harmonize and contrast the composition and colour range. It's important to combine colours and textures to express the visual idea we have in mind, in addition to balancing the cutouts of solid colours with ones with more pronounced elements and textures. It's also important to balance the colour cutouts with ones in black and white.

[**7**] After placing the pieces over the background (landscape), we paint fine lines with gouache (No. 1 or No. 2 brush) to highlight the desired areas.

[**8**] With an ultra-fine-tip marker such as a 0.4, we'll define and specify shapes that will make the scene meaningful (in this case, doors, windows, outlines of houses and stairs). If we want to preserve the abstraction of the scene, subtlety is crucial in this step. In this way, we'll maintain the possibility of multiple interpretations.

Allow the marker dry on the paper. It takes longer for ink to dry on glossy magazine paper due to its lack of porosity and the slightest touch can result in a smudge.

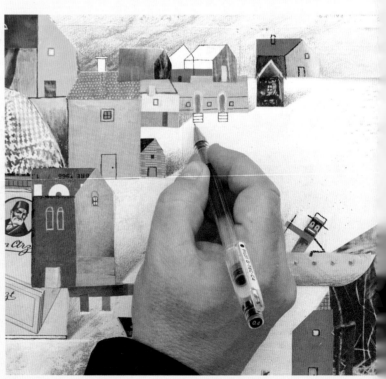

8

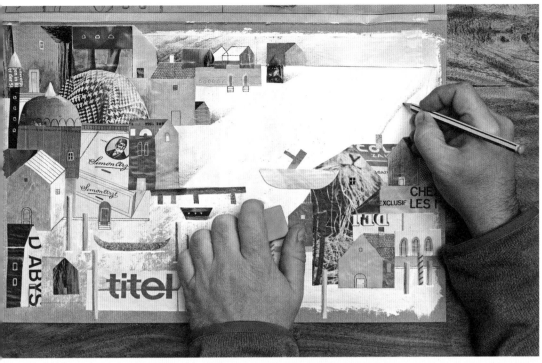

[**9**] We'll use a soft pencil for details and finishes. Finally, we apply a thin layer of fixative so that the graphite doesn't smudge on the surface.

[**10**] For this illustration, we used different materials for the finishes:
— Painted wood for the dock posts
— 2B pencil for shades, smoke and clouds
— White gouache for water sheens

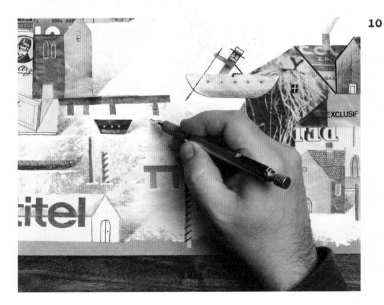

10

A careful review of the whole will tell us if it's necessary to retouch or improve any of the illustration's elements before the photo shoot or scanning.

And now... Turn the page and see the finished illustration!

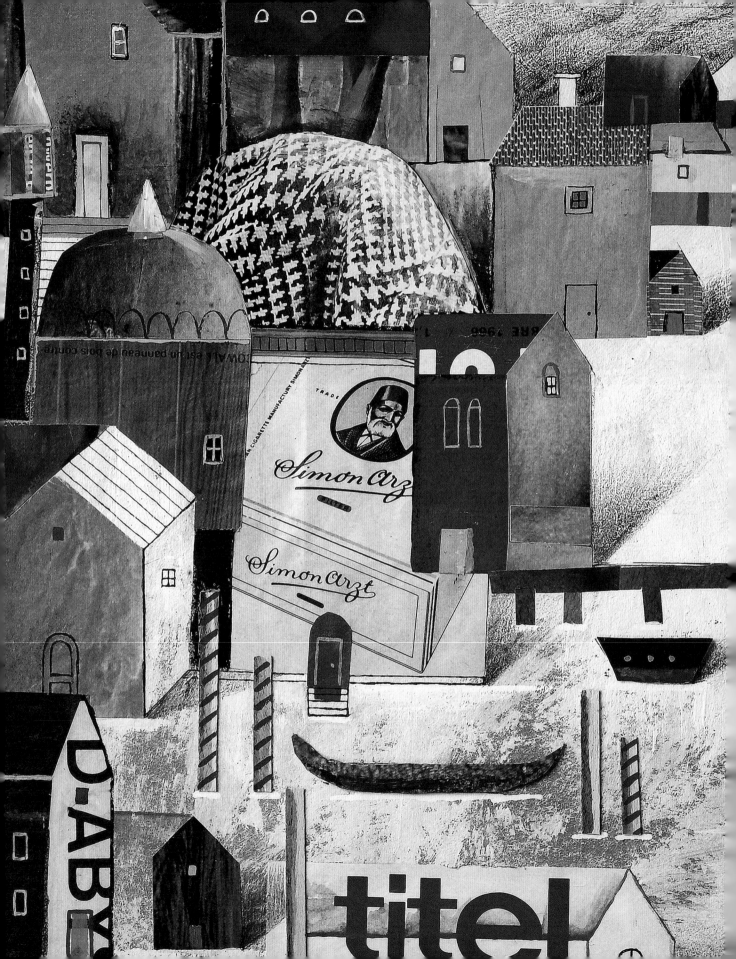

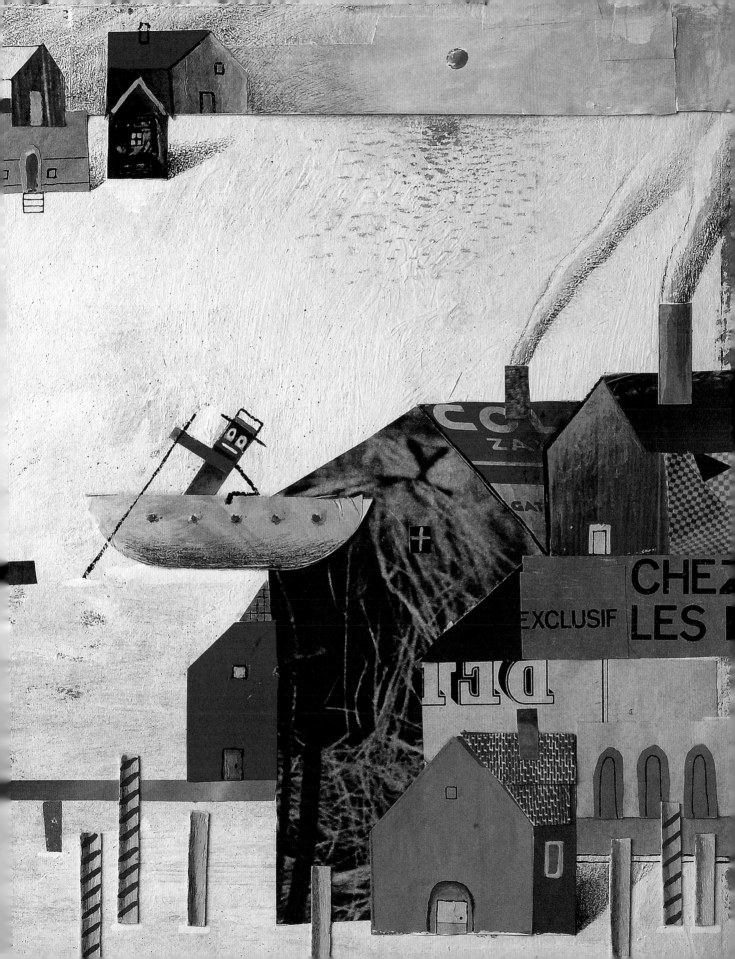

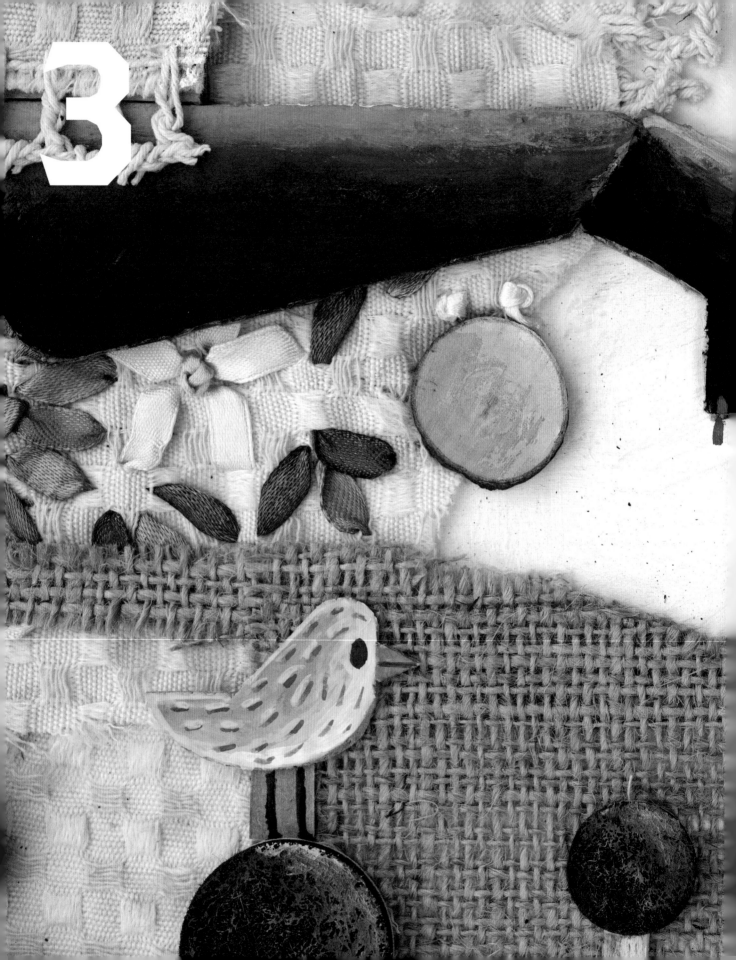

With its infinite variations, fabric is a classic element in mixed media and collage techniques.

Fabric
A MULTIUSE MATERIAL

Now we'll focus on the combination of fabrics of different colour, thickness and texture. As always, we can use other bases to highlight their singularities. In this case, we've decided to work on an illustration based on the classic story Little Red Riding Hood because the characters (especially the wolf/granny) allow us to easily include this chapter's star feature.

MATERIALS

OBJECTIVE
To make an illustration using fabrics with different textures.

MATERIALS AND MEDIUMS
Cardboard
Wood
Sackcloth
Other fabrics
Round pieces of wood
Wire
Nuts
Synthetic foam
Felt
Wooden sticks
Paper flowers
Gouache
Carbon paper
Tracing paper

TOOLS
Metal ruler
Cutting mat
Pencil
Colour pencils
0.4 ultra-fine-tip
 marker
Cutting blade
Scalpel
Scissors
Tweezers
File
No. 1 or No. 2 brush
Thick brush
Plastic palette
White glue

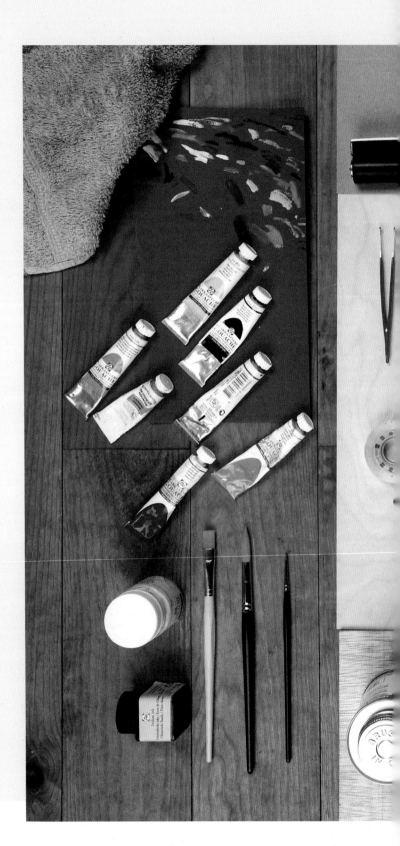

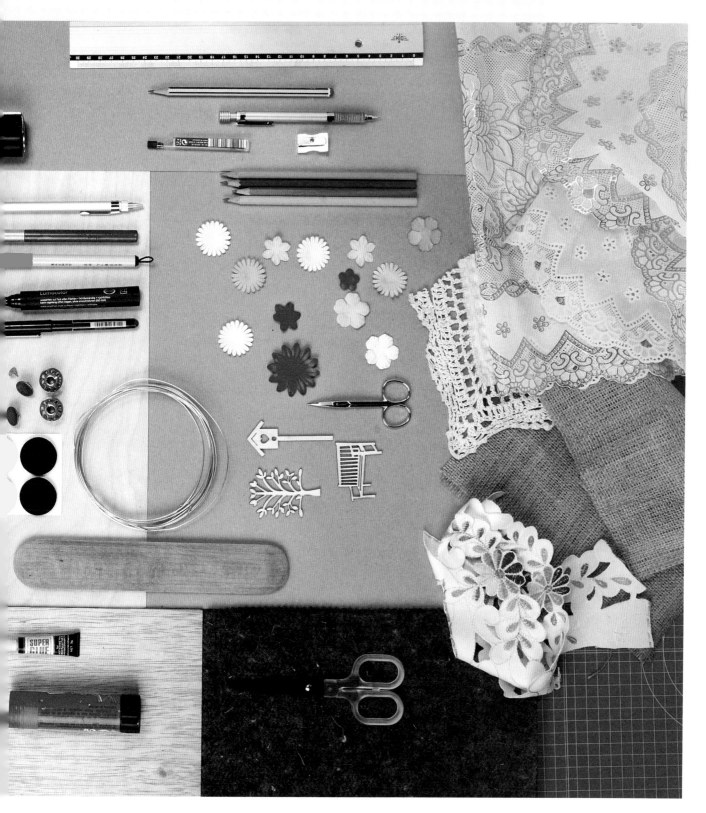

STEP BY STEP

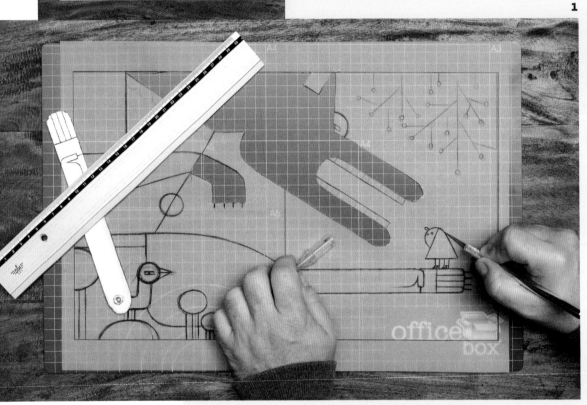

BEFORE GETTING STARTED

Gather material! This can be objects and images that we like, fabrics we keep around the house, interior design magazines, etc. All this will help express what we want to convey and make our illustration more believable and rich in content and shape, regardless of the drawing style we choose.

1

For cutting we'll use:
- Cutting mat
- Metal ruler
- Cutting blade to cut straight lines
- Scalpel to cut curved lines

[**1**] Again, we'll repeat steps 2, 3, and 4 of Chapter 1 (page 16) to ensure that we don't lose sight of the composition as a whole and the pieces we want to work on.

[**2**] We use white gouache to paint the base of the actual illustration (in this case, wood).

[**3**] Using carbon paper, we then transfer the wolf's face from the sketch onto the base. With a 0.4 marker, we create texture for the wolf's face.

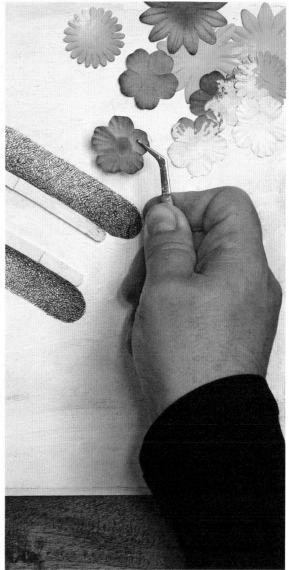

[**4**] We continue gluing pieces obtained from different materials (teeth, one of the paws, the ears...).

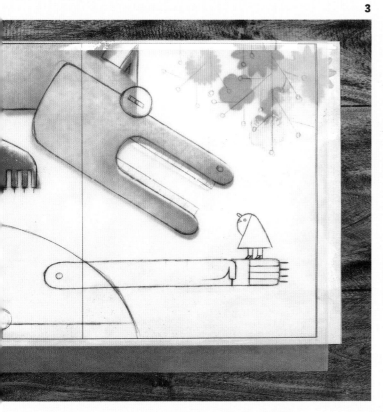

[**5**] We then glue several pink and red paper flowers that we'll later paint white. This will give a flower relief effect to the surrealist tree we've created.

3

4

5

STEP BY STEP

Often, the most common everyday materials can provide excellent results. An example of this are the felt pads that we stick under furniture to protect floors.

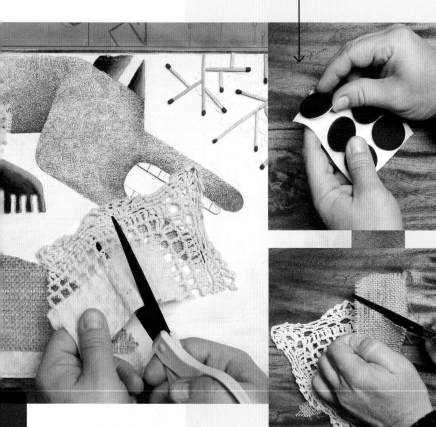

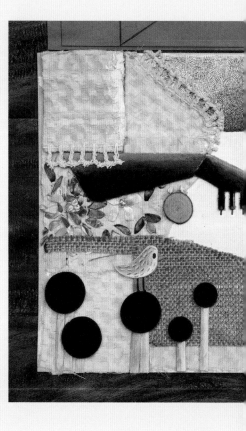

To give definition to the grandmother's clothes, we used old fabrics found at home and sackcloth for the apron. To shape the tree branches, we used matches.

Fabric, in its extensive variety, tends to be a very photogenic material, especially when focused with precision, since it offers a multitude of nuances depending on the manufacture of the fabric used, endowing our illustration with a rich and attractive variety of textures.

[**6**] For the grandmother's glasses, we use wire painted black and tracing paper dyed with liquid watercolour. We then situate the eye, drawn on white cardboard, on the outside of the glasses to highlight her expression.

[**7**] Now we glue the other arm made of synthetic foam and complete the illustration. Next, using red gouache, we paint the wolf's claws and enhance the illustration with different materials: metallic elements, wood, felt protectors for furniture for the treetops, etc.

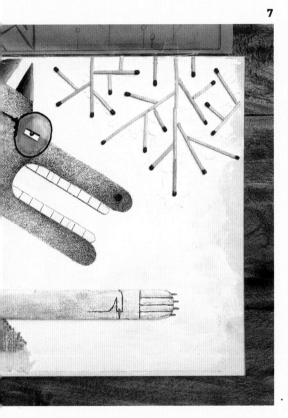

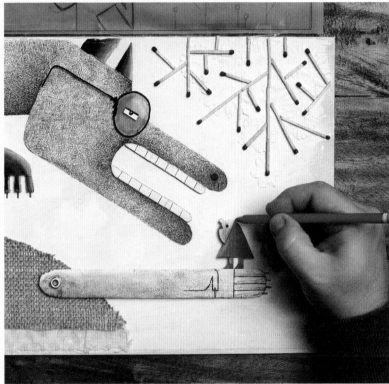

[**8**] Finally, we incorporate our Little Red Riding Hood made of cardboard and paint it bright red, creating a powerful chromatic centre where all the narrative of the scene converges.

[**9**] Lastly, we enhance some areas with a pastel crayon, review the whole illustration and make any necessary improvements to ensure that it's ready for the photo shoot.

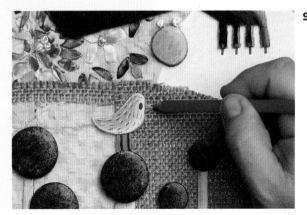

And now... Turn the page and see the finished illustration!

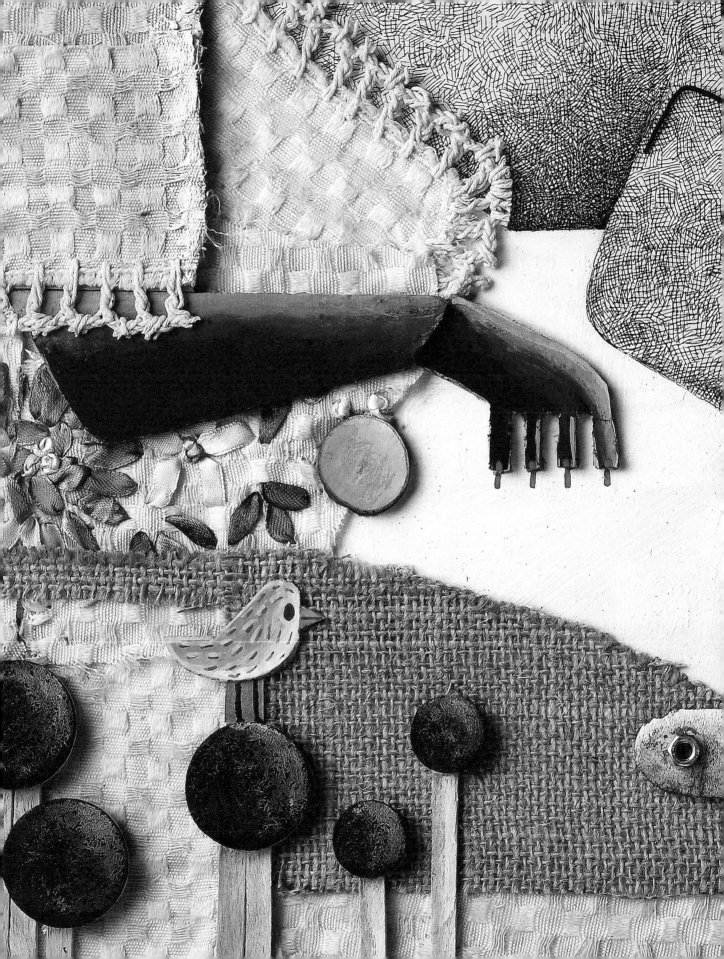

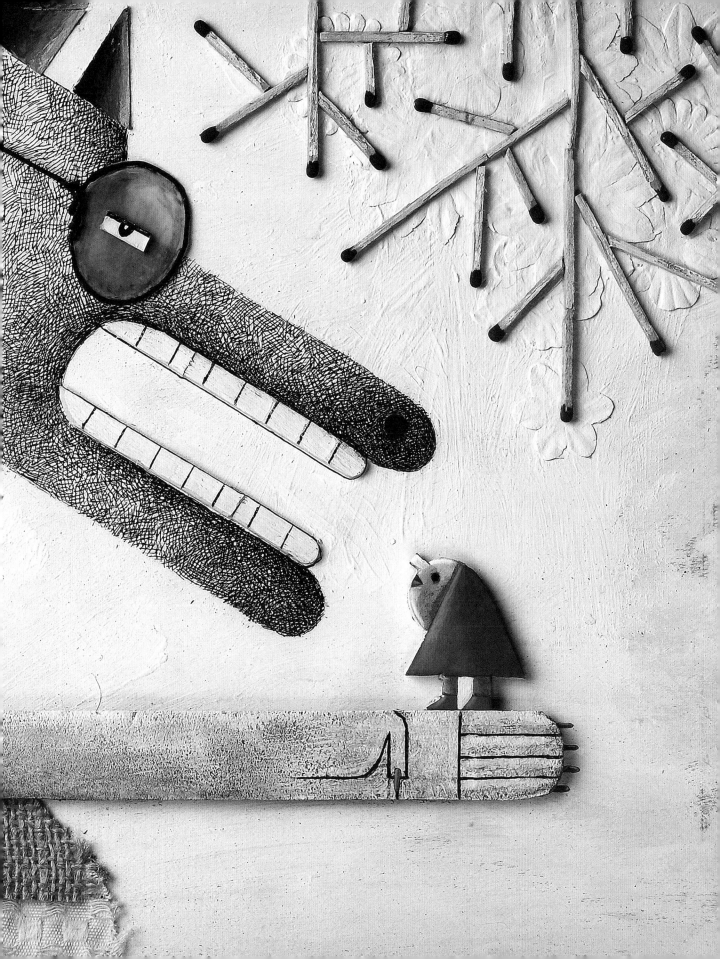

In this chapter, we're going to explore a way to create an illustration with a realistic finish using magazine collage technique and combining it with pencil drawing and other painting techniques.

Collage and light

LIGHT and SHADOWS

In contrast to the previous chapter, where the composition and use of collage were more abstract and free, we'll now try and render (using cutouts from old black and white magazines and newspapers) the volumetric shapes of the human body more or less realistically. Confining ourselves to black and white for these parts of the illustration will help us depict light and shadows more easily.

MATERIALS

OBJECTIVE
Obtaining
volume with
newspaper
and magazine
cutouts.

MATERIALS
AND MEDIUMS

Cardboard
Magazines and
 newspapers in colour
 and black and white
Cut vinyl
Small pieces of custome
 jewellery or pins
Earring
Decorative fabric
Gouache
Carbon paper
Tracing paper

TOOLS

2H and 3B pencil
Colour pencils
Scissors
Punch
Brush
Tweezers
Plastic palette
Roller
Graphite fixative
White glue

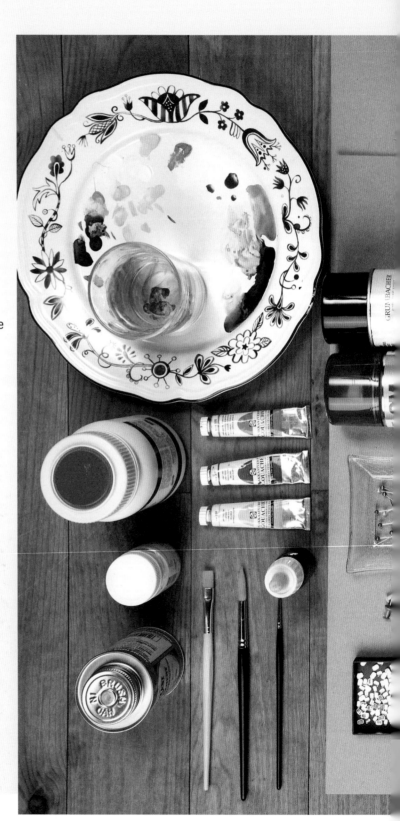

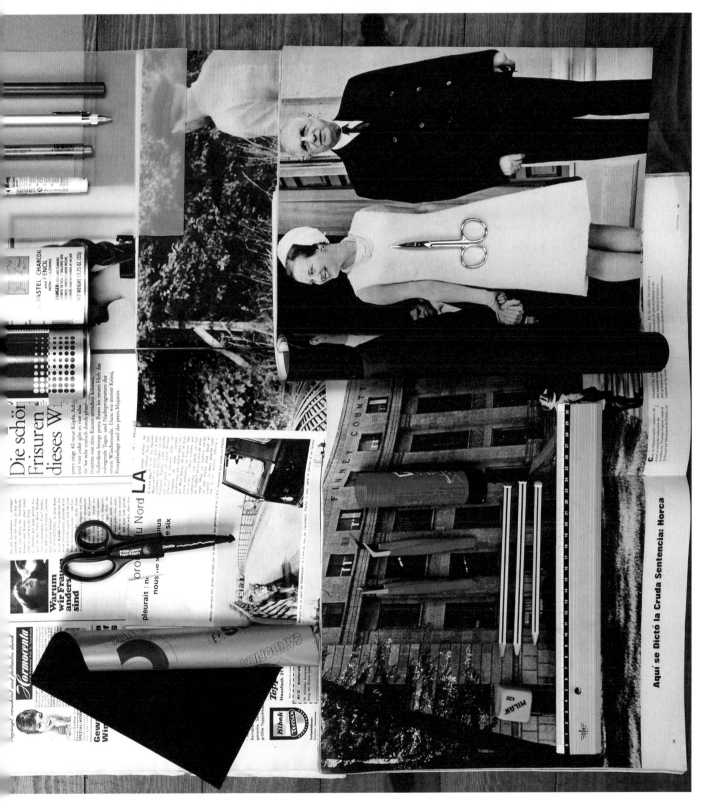

45

STEP BY STEP

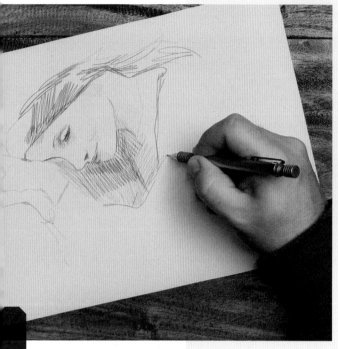

1

BEFORE GETTING STARTED

Once our objective is clear, we collect the photographic and artistic material we're going to need, in this case, black-and-white photographs and prints. Old newspapers are great for this! Look for different compositions and intensities. In this way, the material will help you get closer to what you want to express.

[**1**] First, we'll make the necessary sketches for the definitive drawing, keeping in mind the actual measurements of the final format. It's essential to include light and shade in the sketch. This will allow us to anticipate the different volumes that we'll later create with the magazine and newspaper cutouts.

[**2**] On a piece of coloured cardboard, we apply white strokes of different opacity to achieve a texturized background. This adds depth and will be the ideal base for the pencil strokes we'll apply in the finishing phase.

[**3**] Now we'll trace our drawing using the carbon paper as a guide.

You can use a 0.5 (H) pencil to define the figure and a softer pencil (3B) to create light through more or less intense graduated shading.

8B 7B 6B 5B 4B 3B 2B B HB F H 2H 3H 4H 5H 6H

[**4**] We then cut the photographs and newspapers to create the elements of our composition and place them in some areas while leaving others empty. In this illustration, we use cutouts to create the girl's dress and hair, leaving the areas corresponding to the face and hands empty.

We can use a clean roller to unify the surfaces and flatten up the small gluing imperfections.

4

[**5**] Group and separate the cutouts by the intensity of the colour black (from lighter to darker). Once you've achieved a complete tonal range, you can begin selecting and gluing the cutouts. The idea is to recreate the light and shadows from the sketch through the grey tones obtained from the different groups of selected cutouts. The darker or black ones are set aside for less illuminated areas. We then gradually decrease the tone towards lighter colours until we reach white or ivory, which define brighter areas.

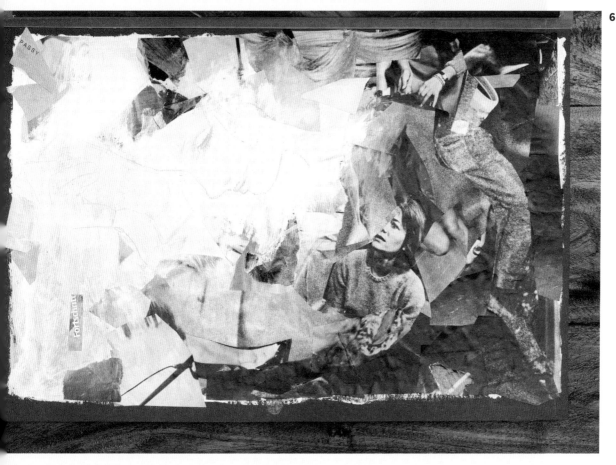

[**6**] Partially cover the central shape with white paint (very diluted) without hiding the drawing completely. In this case, the woman's profile is more hidden but is visible enough to serve as a guide and allow us to make a final pencil drawing.

STEP BY STEP

8

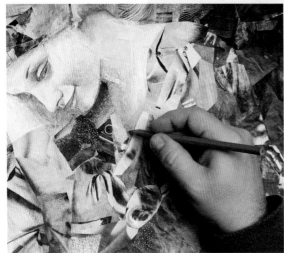

[**7**] Using the light and shadow study of our sketch, we combine the light finishes of the different elements (dress, background and hair) with the white, grey and black cutouts.

[**8**] Once the collage is finished, we'll make the definitive drawing using a 2B graphite pencil. For colour finishes, we'll use soft colour pencils for the eyes, cheeks and neck.

[**9**] In the last step, we place several costume jewellery pieces on the ear and nose to give the final illustration personality and volume.

We recommend fixing the graphite with a fixative. Try spraying only the pencil areas. The plastic layer of the fixative repels materials such as gouache and acrylic. If you don't have a professional fixative, you can use hairspray. The results are excellent!

9

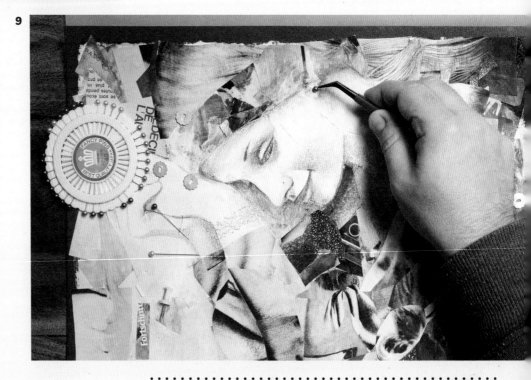

At any bazaar or haberdashery you'll find a multitude of elements that will help to enrich your compositions. The secret lies in observing everyday objects from a creative perspective, always searching for their artistic potential. And believe me: they all have it!

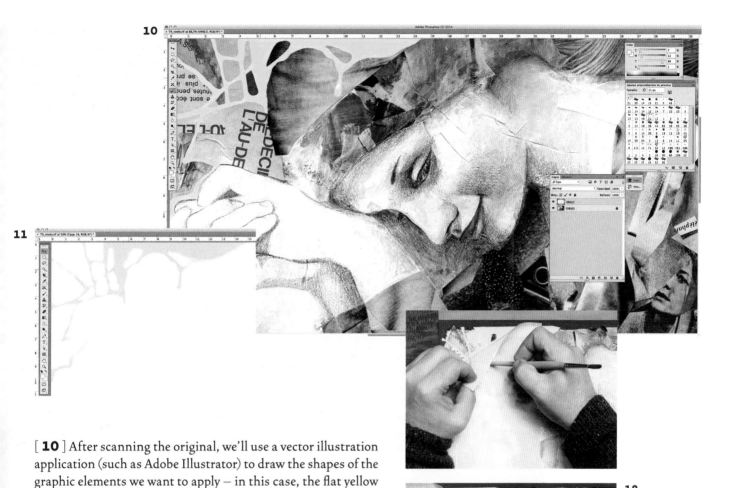

[**10**] After scanning the original, we'll use a vector illustration application (such as Adobe Illustrator) to draw the shapes of the graphic elements we want to apply – in this case, the flat yellow blot – , placing it on a layer on top of the scanned piece.

[**11**] Once the yellow blot is finished, we'll have the vectorized piece that we'll turn into cut vinyl.

[**12**] After a professional printer has cut the vinyl, we'll glue it in its place, applying pressure from bottom to top with an object so that the vinyl adheres to the original. Finally, we'll carefully remove the protective paper.

FOR THE FINISHING TOUCHES

We'll closely review the entire illustration, enhancing any details that need touching up or improvement. At this point, the illustration will be ready for the photo session or final scan.

When the illustration is complete, try half-closing your eyes. If the cutouts have been applied correctly, you'll see a very realistic image. Try doing this with our example!

And now... Turn the page and see the finished illustration!

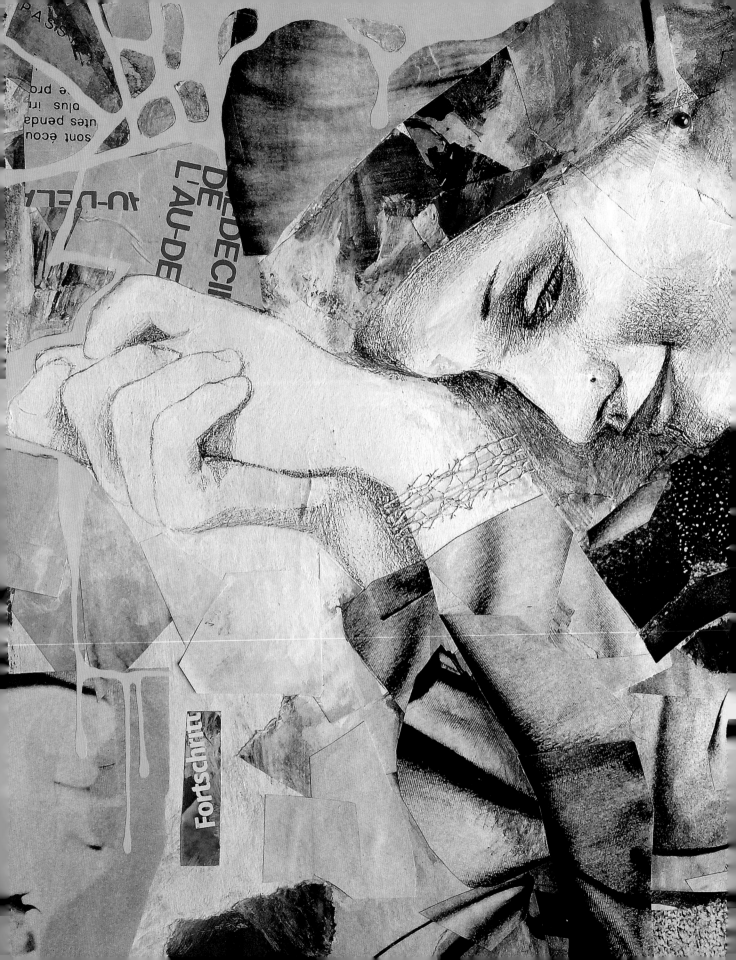

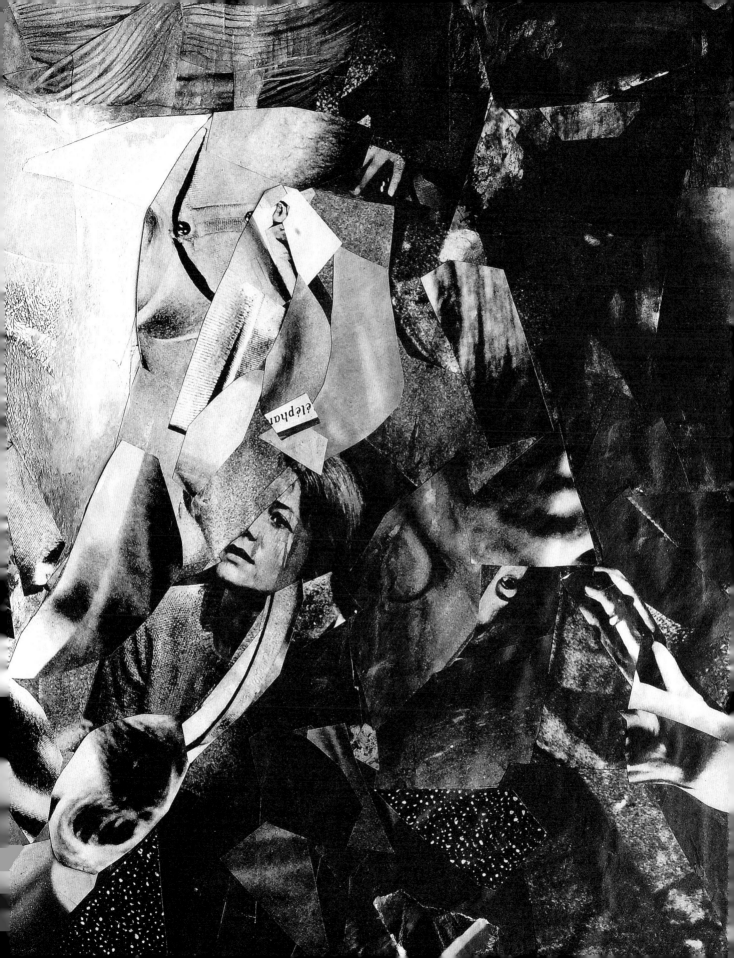

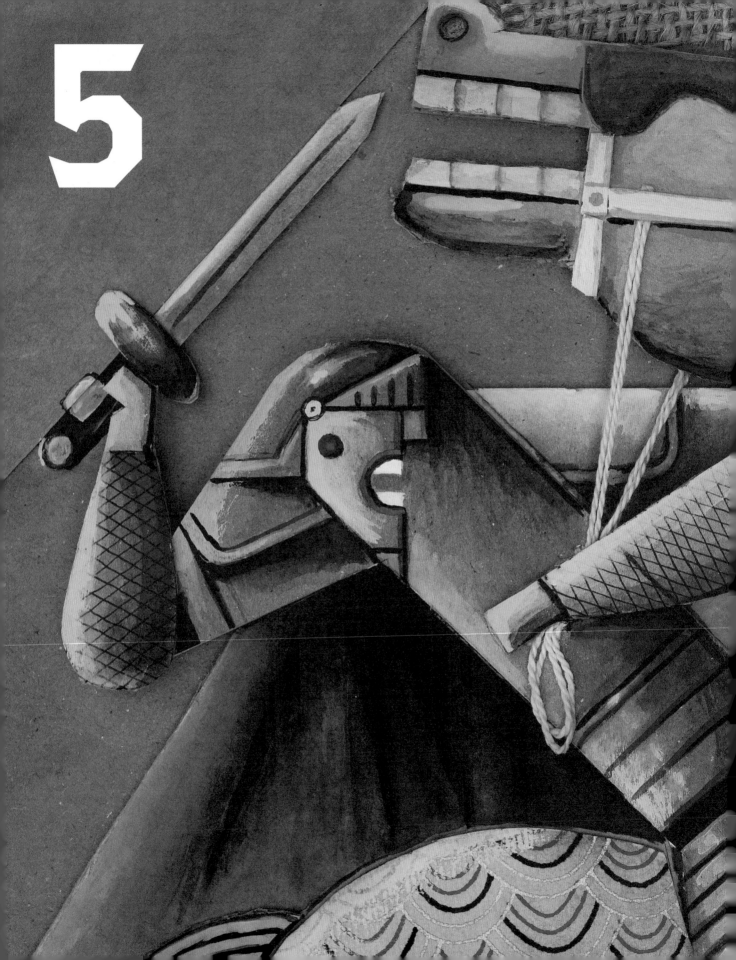

In this chapter we'll create an illustration with different materials but always within the same colour palette.

Colour range

EXPLORING TONES
in a SINGLE SPECTRUM

We're going to work with different textures and materials but without chromatic contrast. A reduced range of colour grants your artwork personality, and the subtle change of hues contributes elegance and style to the composition. Discover how far you can go by manipulating a variety of shades of the same colour.

MATERIALS

OBJECTIVE
To create an illustration with different materials but within the same colour range.

MATERIALS AND MEDIUMS
Cardboard
Sackcloth
Beige poster board
Cork
Fabric paper
Toothpicks
String
Gouache
Felt
Metal rivets
Carbon paper
Tracing paper
Corrugated cardboard

TOOLS
Metal ruler
Cutting mat
Pencil
Colour pencils
Indian ink
Cutting blade
Scalpel
Tweezers
File
No. 1 brush
Thick No. 10 brush
Plastic palette
White glue
Roller

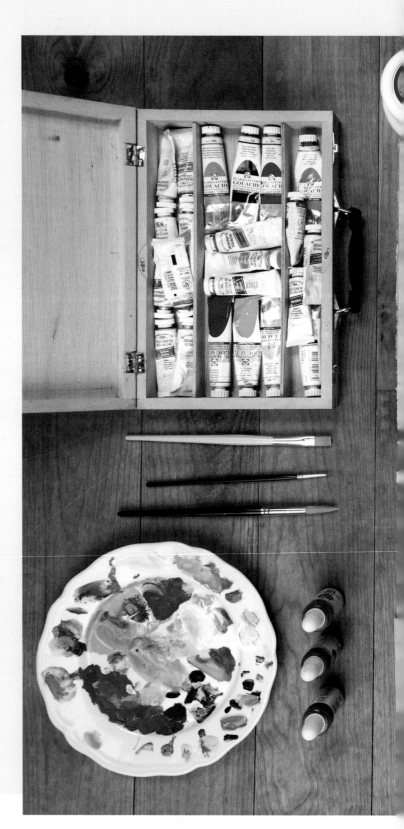

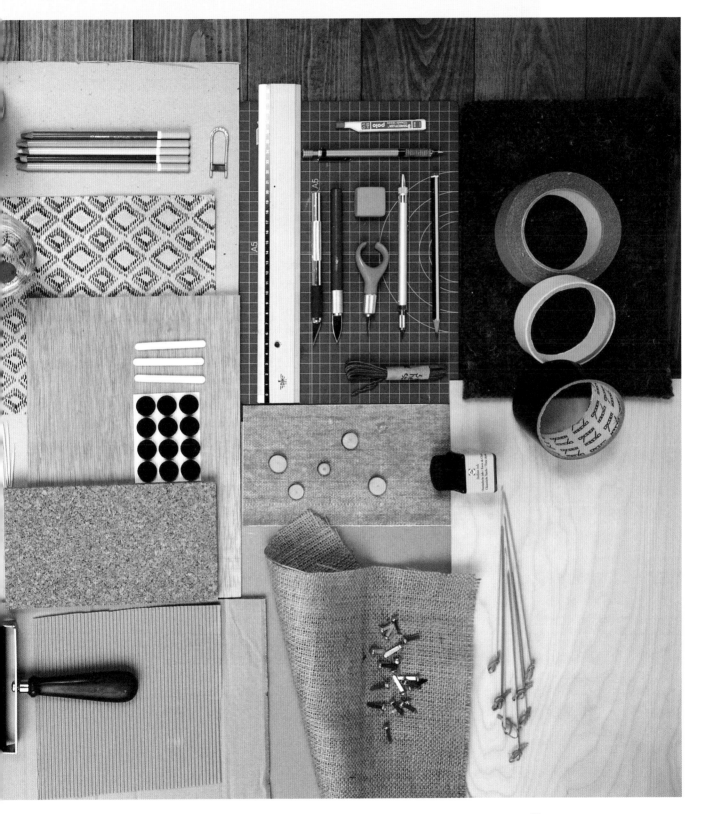

STEP BY STEP

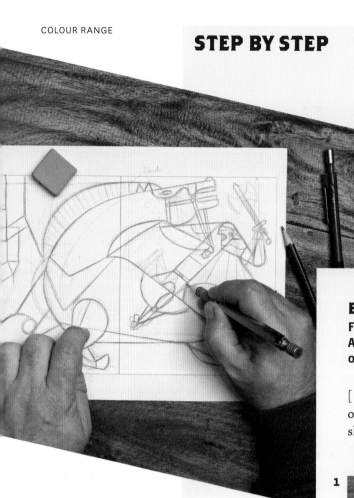

BEFORE GETTING STARTED

First, we need to choose the range we want to work with. After that, we'll select different materials with a variety of textures.

[**1**] In this case, because of the alternatives that tracing paper offers, we've decided to reverse the composition vis-a-vis the sketch in order to highlight the intensity of the scene.

It's important to change the blades of the different cutting blades and scalpels often to ensure that each cut is always clean and precise.

[**2**] We'll repeat steps 2, 3, and 4 of Chapter 1 (page 16). This will allow us to keep our sketch in mind throughout the entire process.

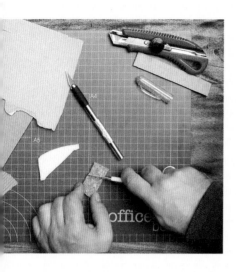

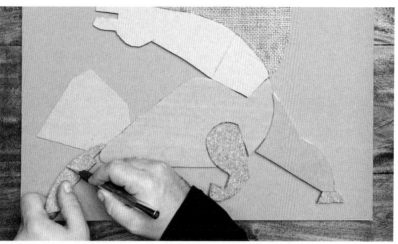

[**3**] Very carefully, with a good cutting blade (new, if possible) and using a cutting mat, we'll cut the different materials to create the pieces.

[**4**] Work with different bases but, on this occasion, prioritize their colour. Choose materials that have a similar colour range (here we have opted for kraft paper colours: cardboard, wood, sackcloth, cork...).

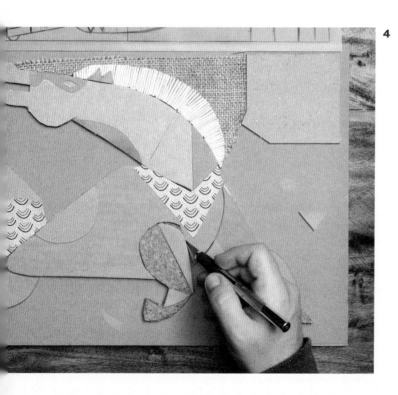

We used metal rivets to create the horse's knees. In this case, we used copper buttons from a pair of jeans. This will give the illustration a touch of originality.

STEP BY STEP

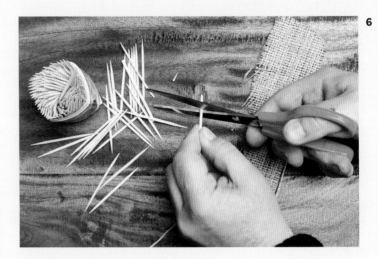

6

We'll use a razor blade to correct and carefully scratch areas where we used too much paint or ink.

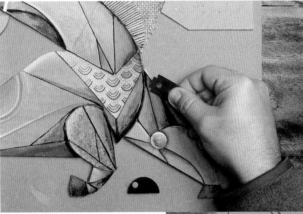

[**5**] After finishing the collage with kraft colour materials, we begin painting with gouache and Indian ink to better define all the areas and characters in the illustration.

[**6**] To create the horse's mane, we cut an ample amount of round toothpicks and glue them onto the base, using the drawing as a guide.

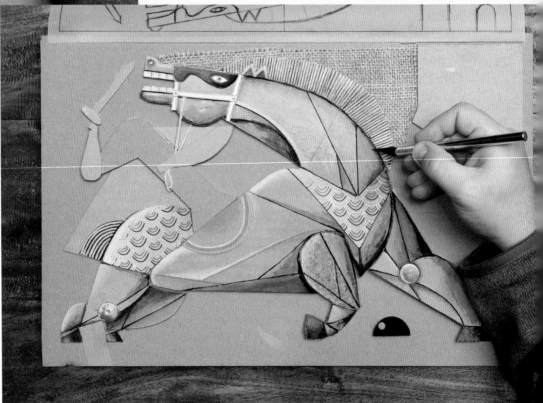

[**7**] We'll finish the illustration with graphite pencil (HB, 0.5) touches and pastel to heighten the colour. If we want the colour to perfectly adhere to the surface, they need to be completely dry.

7

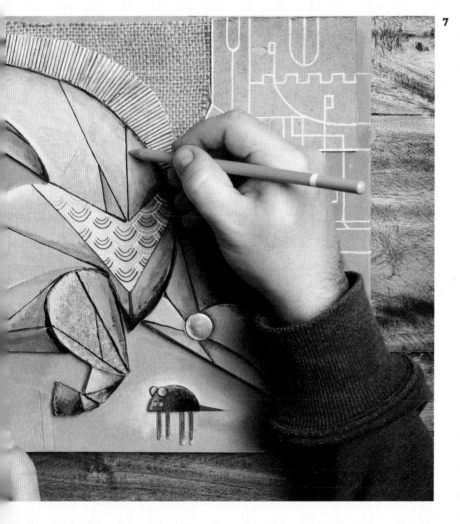

We'll use string for the reins.

Finally, we'll review the piece as a whole and touch up any small imperfections.

COLLAGE AND CUBISM
The term "collage", which comes from the French coller (to glue), didn't acquire artistic meaning until the early years of the 20th century, when painters such as Picasso and George Braque began experimenting with Cubism. They named their work made of pieces of colour paper, newspapers and fabric "collage" This would later revolutionize modern art.

And now... Turn the page and see the finished illustration!

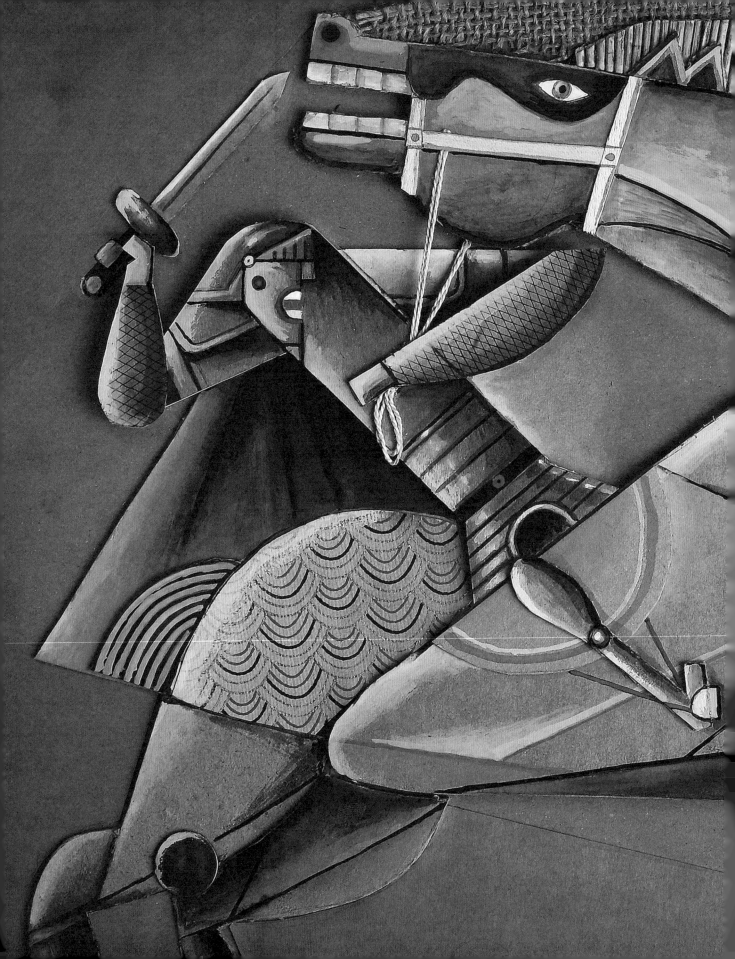

Now we are going to focus our attention on developing the potential of three-dimensional photographic collage.

Three-dimensional collage

A UNIVERSE to EXPLORE

We are going to make an illustration using classic collage methods created from magazine photographs but adding volume to the design. In this case, the main objective of the illustration will be to create timeless personalities by assembling current elements with those of other periods. Formally, we'll achieve this by combining old black-and-white photographs with current colour ones.

MATERIALS

OBJECTIVE
To create
a collage
with volume
combining
photographs
from different
periods.

MATERIALS
AND MEDIUMS
Old and new magazines
Gouache
Canvas paper
Mounting board
Tracing paper
Corrugated cardboard
Aniline
Metal rivets
Bitumen of Judea
Cabinet maker's wax
Paper doily

TOOLS
Metal ruler
Cutting mat
Cutting blade
Scalpel
No. 2 pencil
Double-side tape
Brush for bitumen
Silicone gloves
Rags
Plastic palette
Colour pencil
Marker
Spray glue
White glue

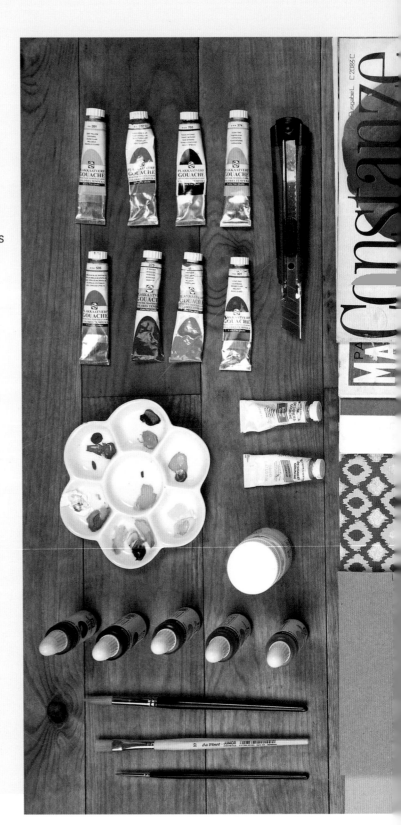

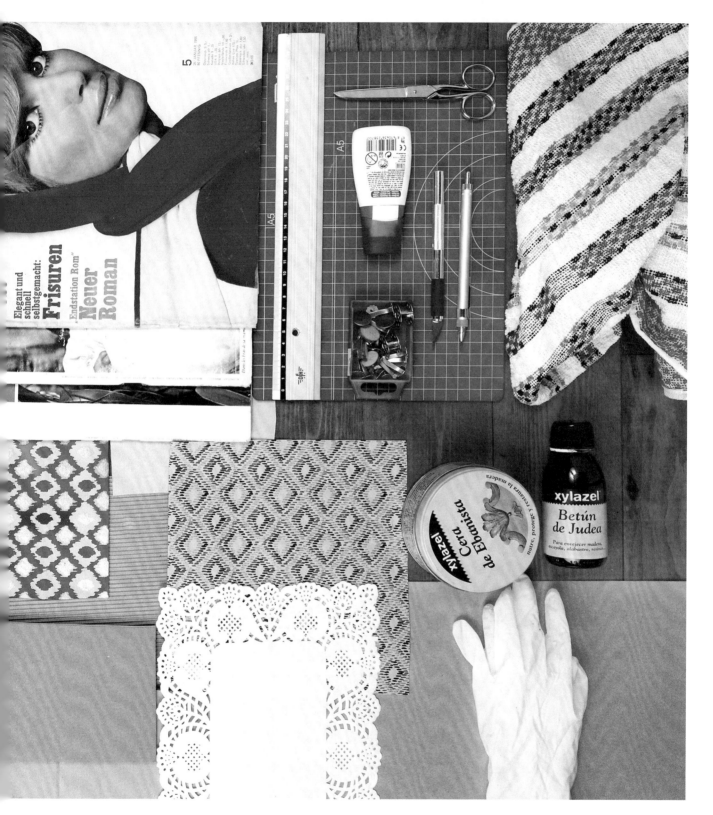

STEP BY STEP

BEFORE GETTING STARTED

We start selecting photographic material in old and current magazines or in our personal files. We can classify the material by periods, content, styles, etc.

1

[**1**] To begin working on this piece, we select a photograph to serve as the base of our volumetric collage. In this case, we've chosen a frame from the classic 1940 comedy *A Philadelphia Story*, directed by George Cukor and starring Katherine Hepburn, Cary Grant, James Stewart and Ruth Hussey.

[**2**] We then repeat essential points 2, 3 and 4 of Chapter 1 (pg. 16).

[**3**] Now we glue the image on a piece of cardboard and cut out parts of the photograph to begin deconstructing it.

> To make straight cuts, hold the cutting blade carefully along the edge of the metal ruler (always on the wide side of the ruler, that is, the non-numerical side).

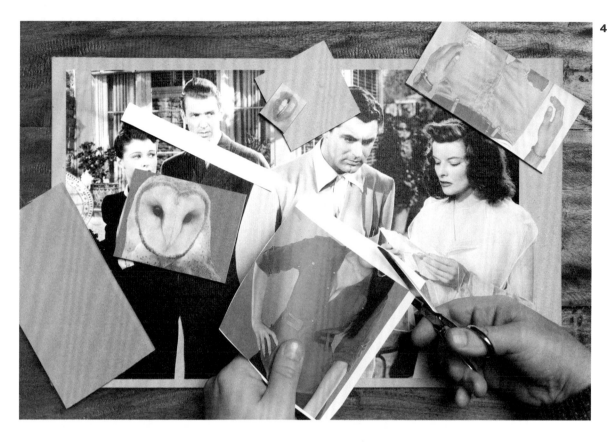

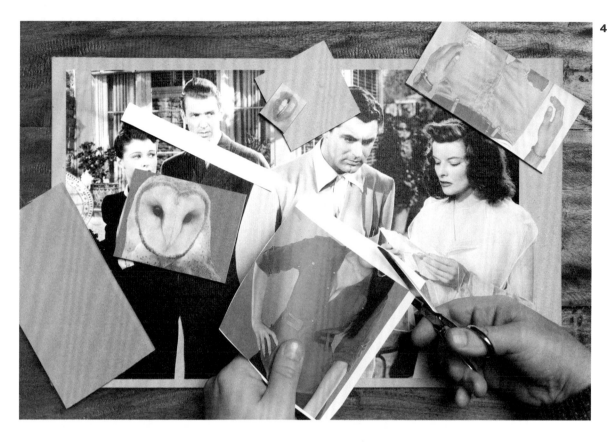

4

[**4**] In current magazines, we look for fragments of photographs that might grant fresh personality to our characters.

[**5**] We then use aniline to colour those areas of the illustration we want to stand out.

By combining elements of the past (black and white) and contemporary elements (colour), we will create hybrid and timeless characters.

5

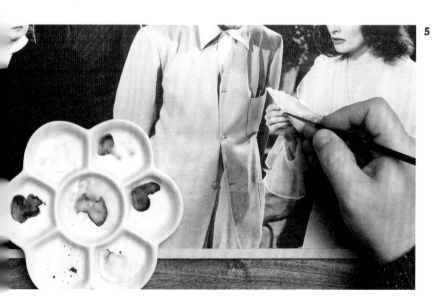

You can use aniline dye to colour in the parts that you wish to call attention to. Since aniline dye is very runny, it is easy to apply and usually provides very good results on most coated papers.

STEP BY STEP

6

[**6**] Glue the selected photographs onto 3 and 5 mm cardboard. This will give your collage the volume that we want and, if we photograph the piece, will enhance any relief and shadows.

[**7**] You can apply non-photographic materials to enrich the image: a doily for the finishes of the protagonist's dress, printed fabric for the vest and pants, corrugated cardboard for the background and a metal rivet to highlight the waist.

7

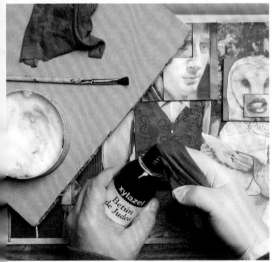

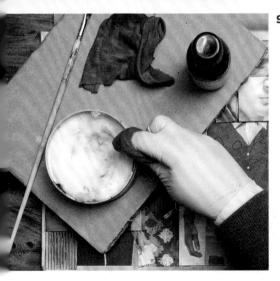

8

9

[**8**] After gluing all the pieces to the base, apply cabinet maker's wax and then bitumen of Judea to age and unify the image.

[**9**] You can control the bitumen's intensity with a rag and cabinet maker's wax.

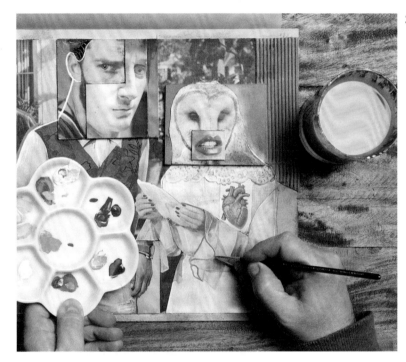

10

[**10**] Once the bitumen of Judea and the wax are completely dry, you can paint some lines with gouache to call attention to specific elements of the composition, thus creating contrast between the aged finish and bright colours.

At the end, as always, you should check the piece as a whole, outline details and make the piece ready for a photo shoot.

And now... Turn the page and see the finished illustration!

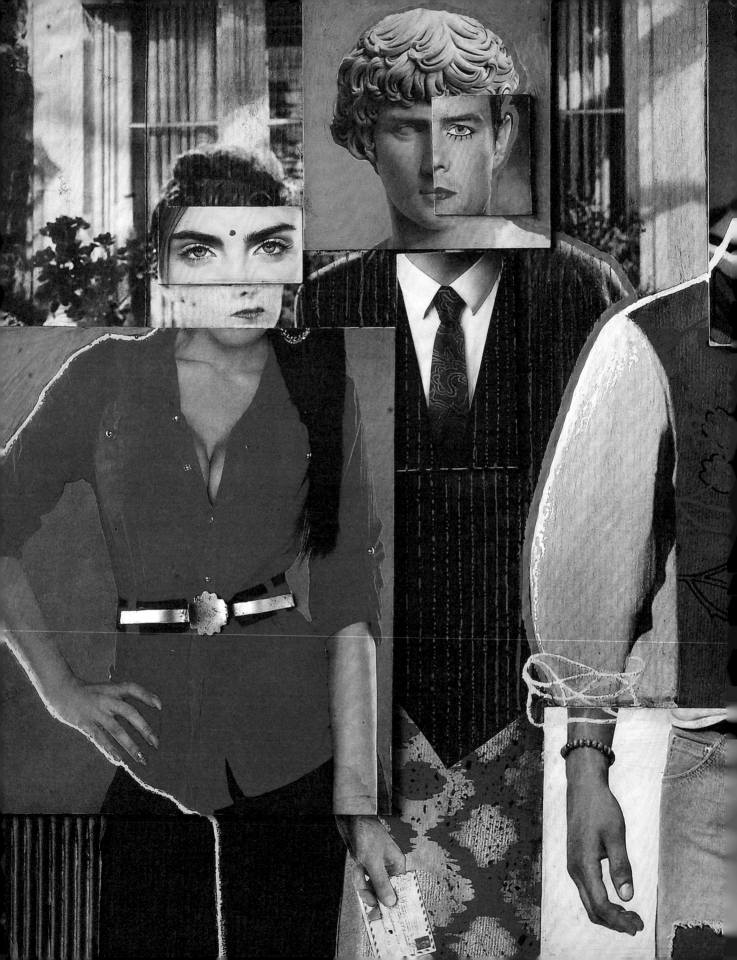

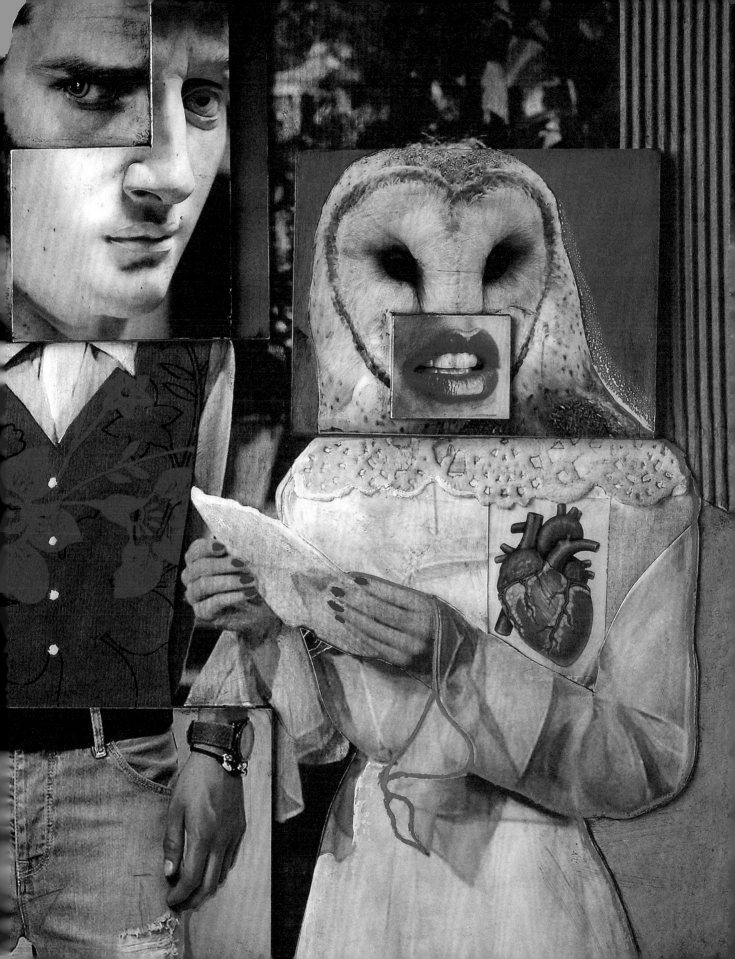

In this chapter we will create a illustration with volume: mini sculptures that we'll incorporate into the final piece.

Volumetric illustration

SCULPTING CAN ALSO BE ILLUSTRATING!

To do this, we'll use playdough, which will allow us to sculpt the elements that we need. Also, once it dries, painting it will be easy. These volumes contribute a very particular kind of depth to the illustration while also adding visual richness.

MATERIALS

OBJETIVE
To make an
illustration
with volume
(mini-sculptures).

MATERIALS AND MEDIUMS
Cardboard
Black sandpaper
Metal rivets
Playdough
Adhesive paper
Gouache
Tracing paper
Carbon paper

TOOLS
Metal ruler
Cutting mat
Pencil
Cuttig blade
Tweezers
File
No. 1 and No. 2 brush
Thick brush
Plastic palette
White glue

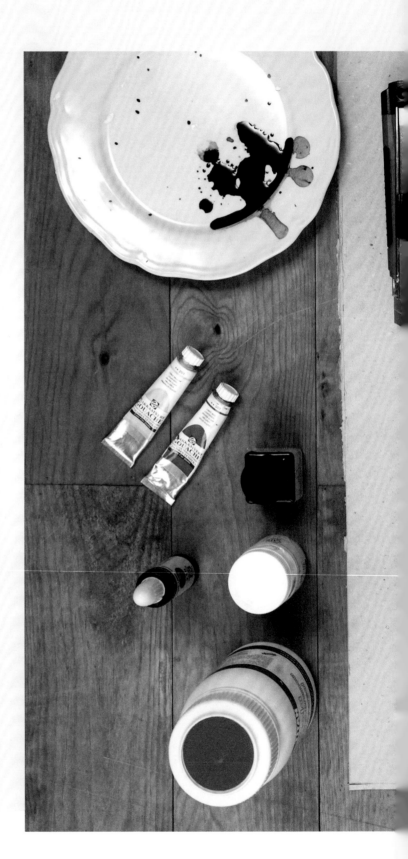

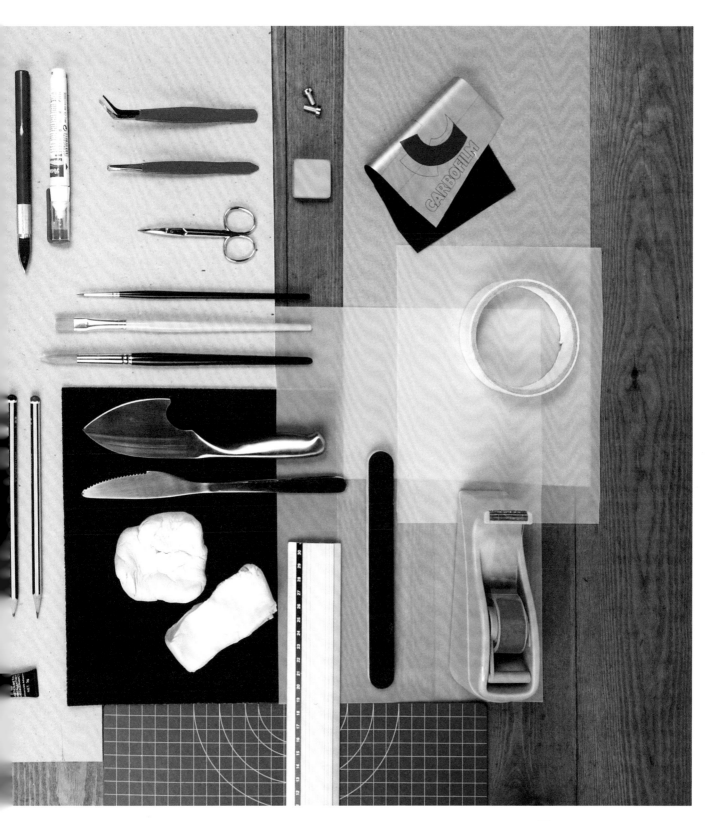

STEP BY STEP

BEFORE GETTING STARTED

After completing the selection process and collection of materials, cut a 5mm-thick mounting board to the desired size. This will serve as the base of the piece. We need a stable base that can support a certain amount of weight.

1

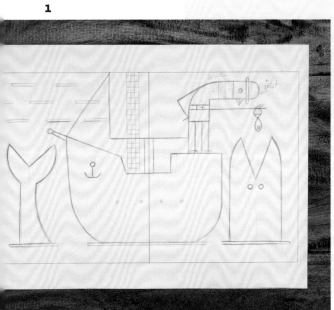

[**1**] Repeat points 2, 3 and 4 of Chapter 1 (pg. 16). This will allow for a controlled composition at all times.

[**2**] Use black sandpaper as the base of the drawing. Glue the sandpaper to the cardboard, which we will later paint black.

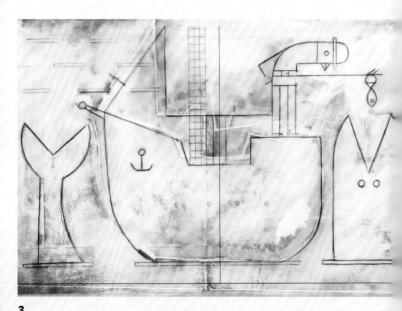

3

[**3**] Using a piece of yellow tracing paper, transfer the outline of the pirate ship to the sandpaper and then trace the outline of the ship (approximately 2mm wide) with white adhesive paper, which you will then glue, turning it into a "mask" or "reserve".

2

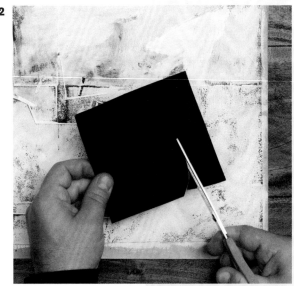

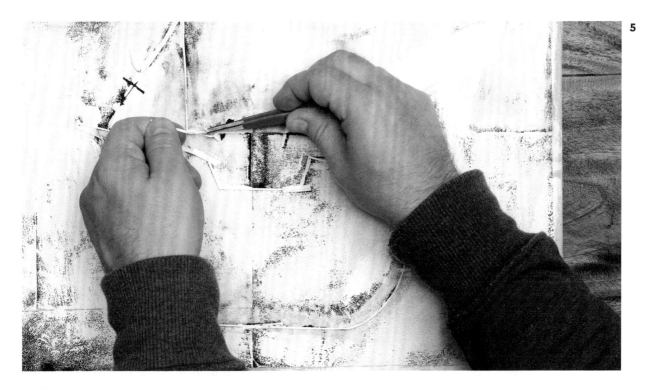

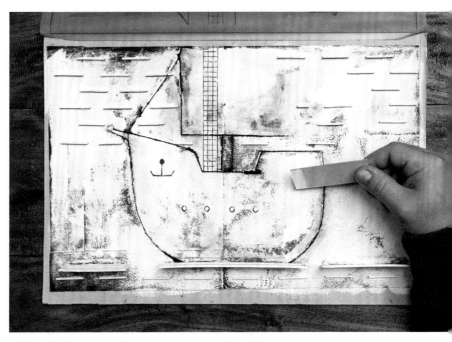

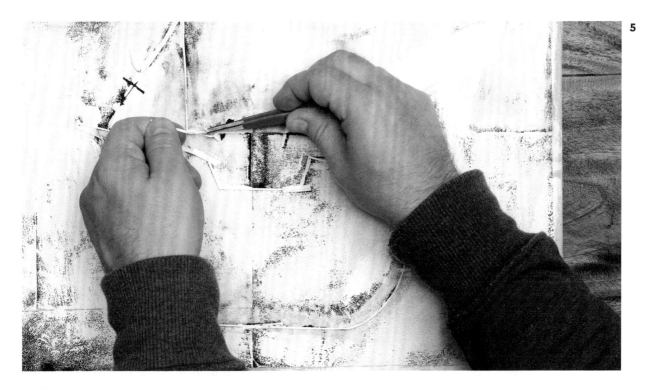

[**4**] Paint the entire piece of sandpaper with white gouache, using little water and taking care not to rupture the outline of the white adhesive paper (mask).

[**5**] After the paint dries, carefully remove the adhesive paper using tweezers. The white gouache will have covered all areas except for the ones that we reserved with the mask. Removing it, the black outline of the drawing of the ship will appear.

[**6**] Cut 2mm-thick strips of cardboard and paint them white to create ocean "waves" within the surrealist scence that you have created.

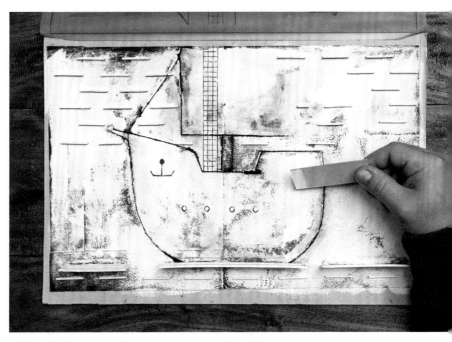

6

STEP BY STEP

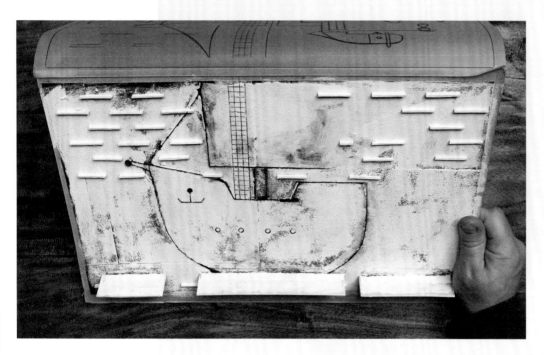

Throughout the process, you should perform light tests to ensure that, during the final photo shoot, the volumes of the pieces in the illustration provide the depth that you want (see page 114).

[**7**] Use the same 2 mm cardboard to give shape to the pirate.

[**8**] With a thin brush (No. 1) and black gouache, draw the arms, legs, hands and details that you want to outline.

[**9**] Sculpt the whale or giant fish of the drawing with playdough. Playdough is available in variety of colours. In this case, we used white playdough, which hardens when it comes into contact with the air. You'll find many types and brands of playdough in the market.

9

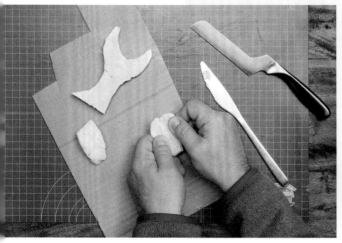

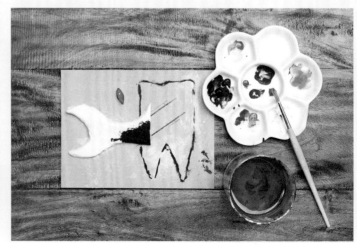

[**10**] Once the playdough is dry, paint the pieces with black and white gouache.

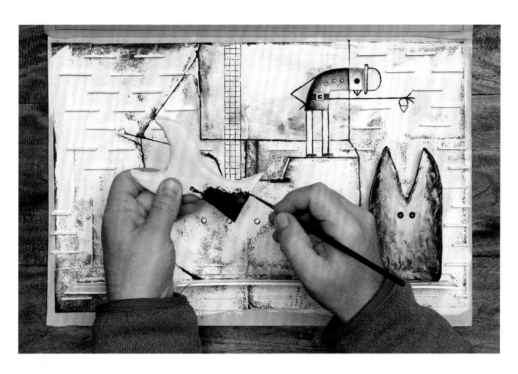

[**11**] Glue the volumes to the medium using white glue. Place them and unify them chromatically according to their surroundings.

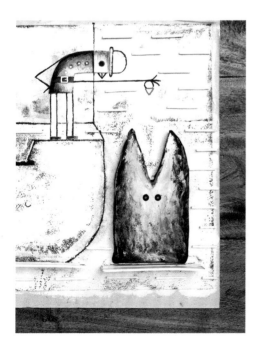

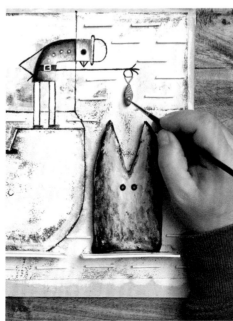

We use colour to highlight certain elements of the illustration that we want to call attention.

And now... turn the page and see the finished illustration!

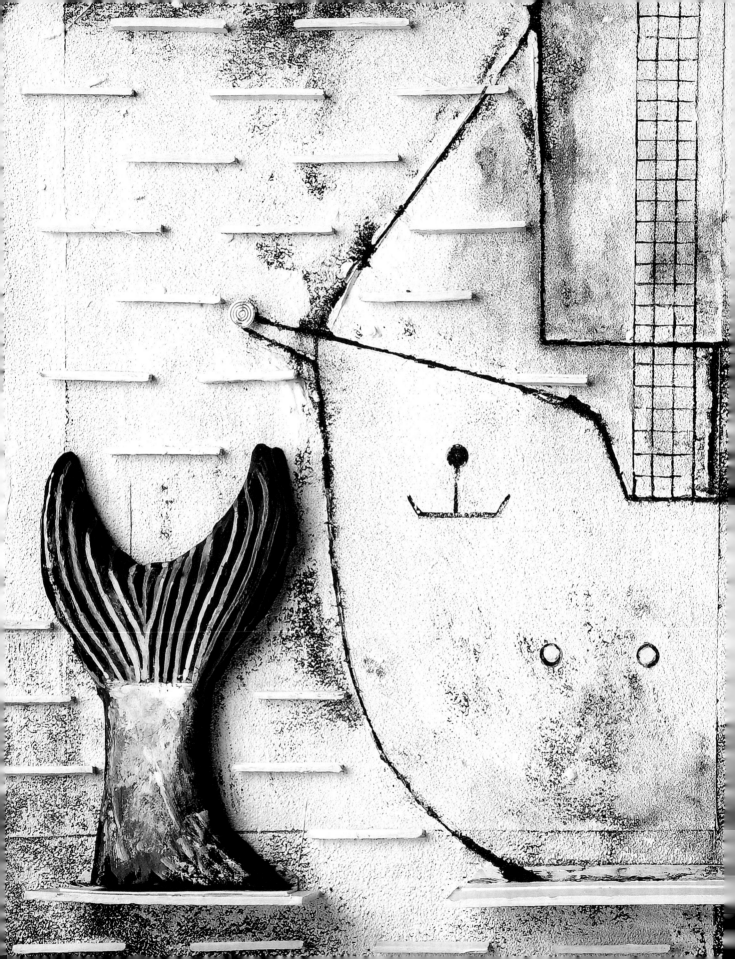

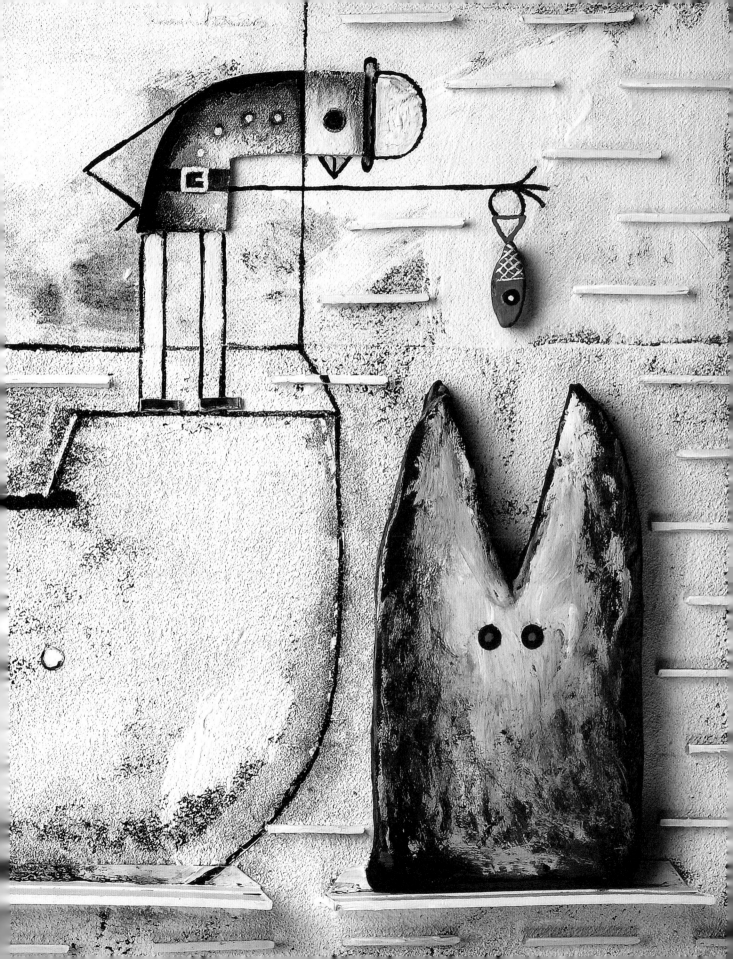

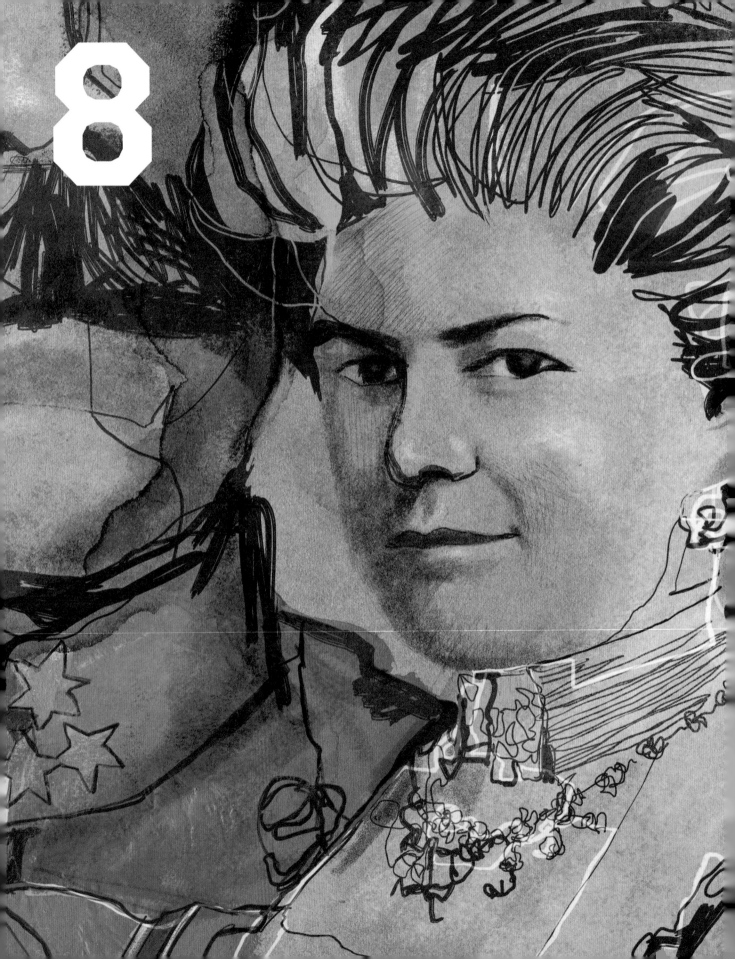

In this case, we've been commissioned to illustrate a magazine article with historical content.

Hand-crafted or digital?

We are going to practice how to include digital finishes in a handcrafted illustration. The idea is to achieve a hybrid of the digital and pictorial, with the aim of granting the piece a "handmade" finish. Taking advantage of the wide range of resources provided by an image processing programme such as Photoshop, we can retouch, change, test and enhance aspects which would be impossible to control in a purely handcrafted original. If we combine both techniques effectively, the results can be spectacular!

MATERIALS

OBJECTIVE
To make
a digital
illustration
that appears
handmade.

**MATERIALS
AND MEDIUMS**
Computer
Cardboard
Gouache and
　watercolours
Paper

TOOLS
Pencil
No. 2 brush
Plastic palette
Photoshop or another
　image processing
　programme

STEP BY STEP

BEFORE GETTING STARTED

Properly document the subject in this case, a reflection on the causes and origins of World War I. It's important to make a good selection of documentary material in order to provide a solid historical foundation that will allow you to faithfully reproduce the aesthetic of the period.

2

In this composition, we will leave ample unillustrated space for laying out the text.

You can enhance the light effect in certain areas with Tipp-Ex.

[**1**] The illustration will appear on the two-page entry spread of a magazine article, accompanying the title and brief introductory text. For this reason, we've left an empty space (unillustrated) in which the text can be easily laid out (see pgs. 90-91).

[**2**] Make pencil sketches of the composition, keeping in mind the actual measurements of the final format. Think about where you want the light to come from; this will help give you an idea of the different volumes. Through traces of more or less intensity depending on the direction of the light, you can express the chiaroscuro that you want to achieve.

[**3**] Using a piece of tracing paper, carefully transfer the outline of the sketch onto a piece of cardboard (kraft) to mark areas you want to colour later.

[**4**] Colour the background with gouache and liquid watercolour (aniline).

[**5**] To work on an illustration in digital format:
1. Scan the sketch;
2. Scan the coloured cardboard background (kraft) in high resolution;
3. Place the background in one layer and the sketch in another;
4. To superimpose the layer on the background, we apply the blending mode of each layer (multiply) of the "sketch layer".

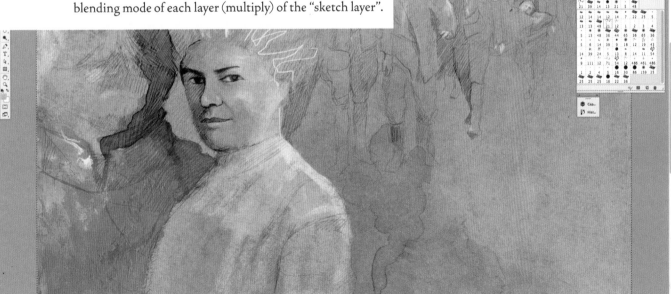

STEP BY STEP

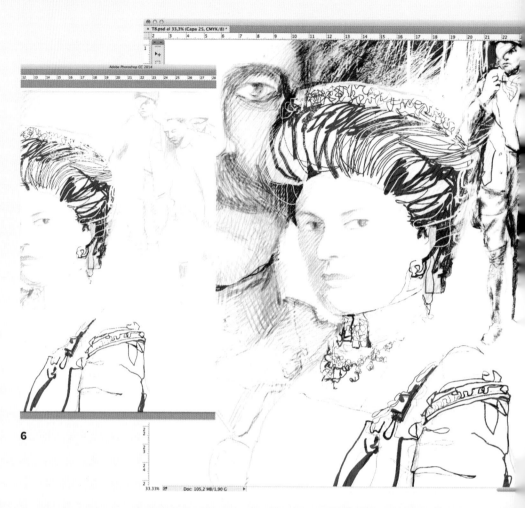

To draw this scene with the image editing programme, we customised a series of brushes with different textures, intensities and thicknesses that, skillfully combined, will give the illustration a more handcrafted finish.

6

[**6**] For a successful illustration, deactivate the background layer and trace the sketch (which we'll keep in another layer and at a lower opacity to facilitate its tracing) with the different textured Photoshop brushes that we customised.

[**7**] Finish the illustration with colour details also obtained with the customised Photoshop brushes. The result is a hybrid finish with balanced digital and manual features.

[**8**] The digital process allows us to try many different effects: types of tracing, textures and colours, in addition to numerous blending mods of each layer, without ruining the background. These tests are not feasible when working in manual mode, directly onto the cardboard.

7

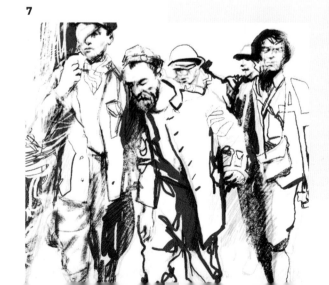

If the illustration is applied to a publishing medium (book, magazine, etc.), we recommend leaving an area free of illustrated elements in the middle of the double page. We're referring to an area measuring approximately one centimetre on each side and throughout the vertical extension of the illustration. It's important to keep this area empty so that important details of the drawing aren't lost, due to the stitching and curvature of the pages in the central area of the book, which presents a slight obstacle to vision.

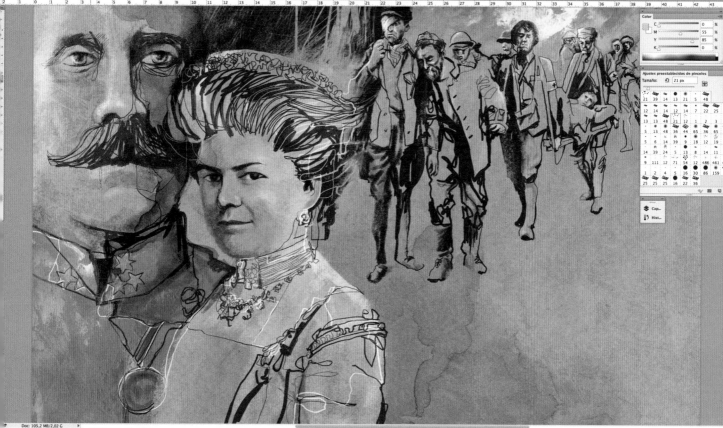

9

[**9**] Take time to check your work. Study the result and outline the details that you want to retouch or enhance. In this case, we left it ready for the subsequent layout of the book by the magazine's design department.

And now... turn the page and see the illustration finished and laid out!

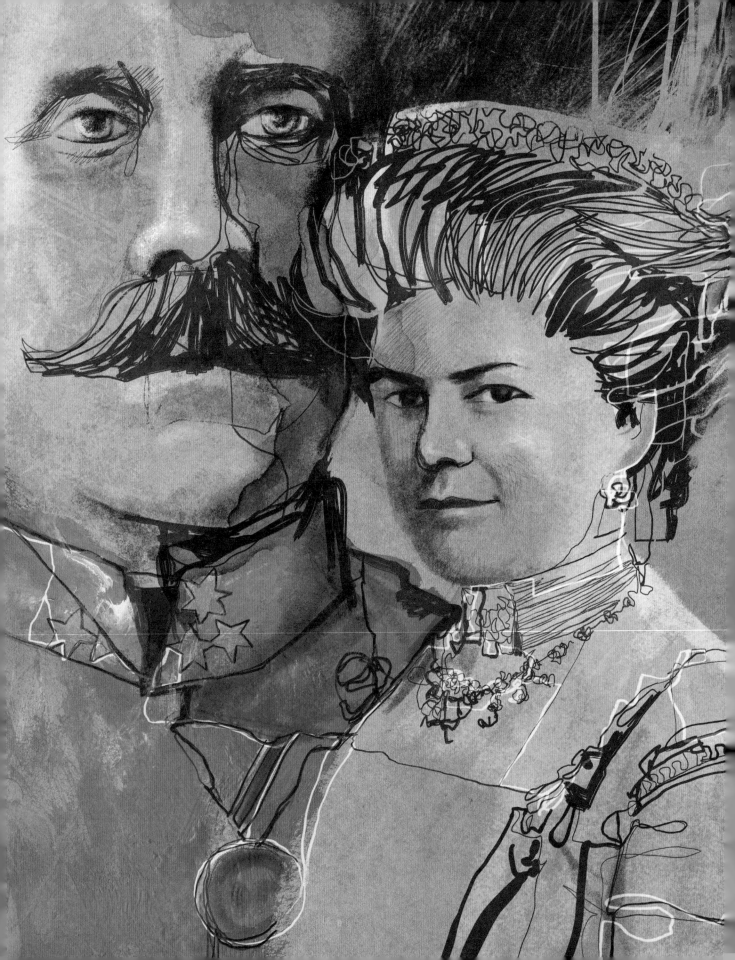

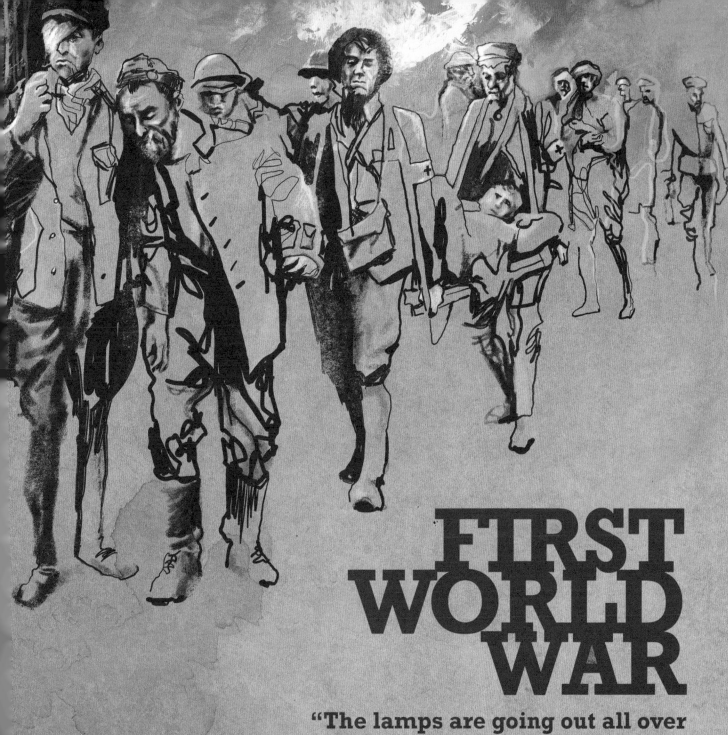

FIRST WORLD WAR

"The lamps are going out all over Europe, we shall not see them lit again in our life-time".

On August 3rd 1914, on the eve of Britain's entry into the First World War, the Foreign Secretary Sir Edward Grey predicted with these words the terrible years that were looming over Europe, while looking into the London sunset with a friend, from his office in Whitehall.

A theatre stage is an ideal space for working
with different depth planes.

The NARRATIVE POSSIBILITIES of an
illustrated theatre

First, we're going to create a stage as decoration.
At the same time, we'll draw our own characters and,
finally, do a photo shoot of the entire composition,
playing with the different possibilities that the
distribution of the elements over the decoration
offers us. Illustrate a theatre set with your characters.
In addition to being fun, it provides an infinite number
of narrative formulas!

MATERIALS

OBJECTIVE
To make an illustration with different depth planes in order to create a small theatre set.

MATERIALS AND MEDIUMS
Gouache
Thick cardboard
Photograph for collage
Wooden sticks
Chopsticks
Tracing paper

TOOLS
Metal ruler
Cutting mat
Tape
No. 2 pencil
Plastic palette
2H and 2B pencils
0.4 marker
Punch
White glue
File

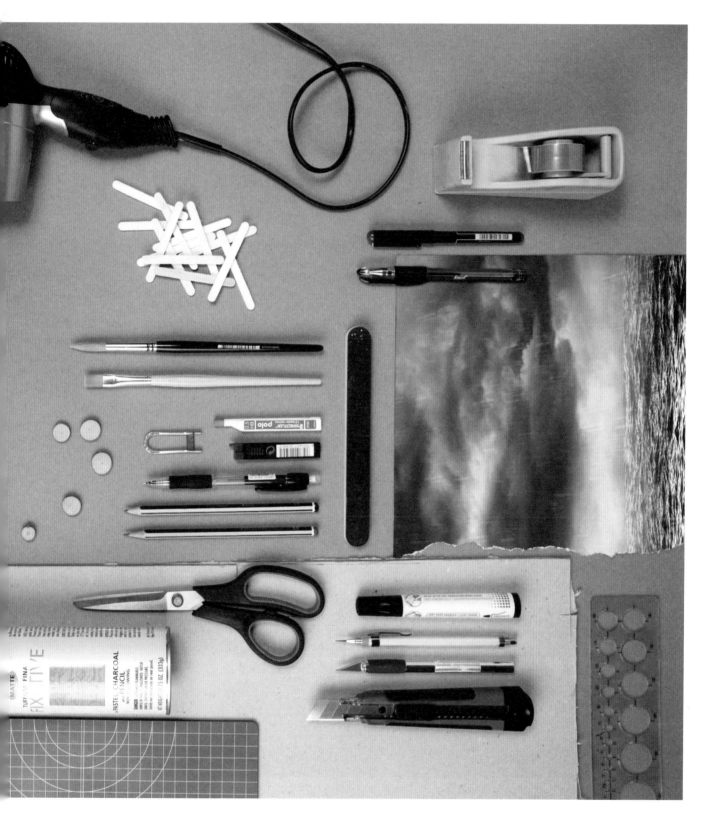

STEP BY STEP

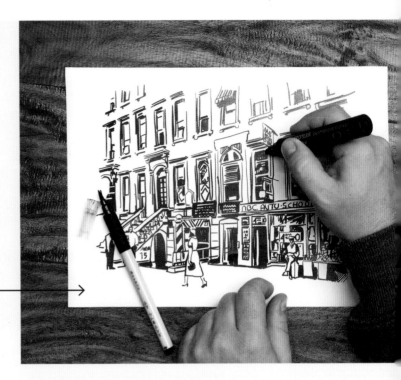

To create our scene, we collected photographic material from the period. In this first stage, we'll make several sketches that will express the atmosphere needed to familiarise us with the spirit of New York in the 1930s.

BEFORE GETTING STARTED

In this case, we recommend that you read the entire chapter carefully. Once you have a good grasp of the "step by step", your ideas of places, settings, characters and stories with flow more freely. At this point, you can start the documentation process with which you're already familiar.

[**1**] First, we'll make pencil drawings of the characters that will appear in the scene.

[**2**] Draw the scenario where the action in the scene will take place: here, a New York building facade in the 30s.

1

2

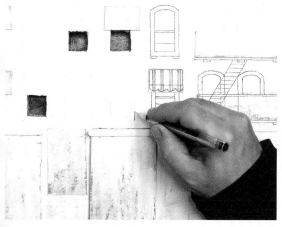

[**3**] Create the scenario on 1 cm-thick cardboard and paint it with white gouache in brushstrokes of varying thickness and opacity. The brushstrokes should overlap and not be homogeneous. To achieve this, it's best to use little water and a dry brush.

[**4**] After the paint dries, begin to lightly draw with a hard lead pencil (2H) all the outlines that you will later go over with a very fine 0.4 black marker.

[**5**] Use fragments of wooden sticks to add volume to certain areas of the building.

[**6**] Make holes in the cardboard to create windows. In this way, the light that we'll place behind the scene (in the photo shoot) will create the effect of an illuminated interior in a city at night.

[**7**] After the facade is complete, glue on a photographic sky in black and white, in addition to some store and establishment signs to give a sense of verosimilitude and contrast to the scenery.

[**8**] Lastly, create shadows and volume with a soft pencil (2B). Add a thin layer of fixative to the piece so that the graphite doesn't smudge on the surface.

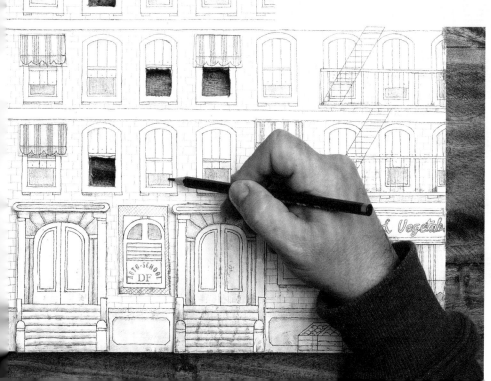

8

STEP BY STEP

9

You can cut and paste store signs and street names freehand or you can create them digitally in the different necessary sizes. Afterwards, print and paste them onto the original (like in the example).

[**9**] With a piece of cardboard identical to that of the facade of the houses, create the ground of the theatre set using gouache, marker and pencil.

[**10**] Design the characters and then use the file to file down the imperfections of the paint and the unions of the different materials. This will give the creation a polished and well-defined appearance.

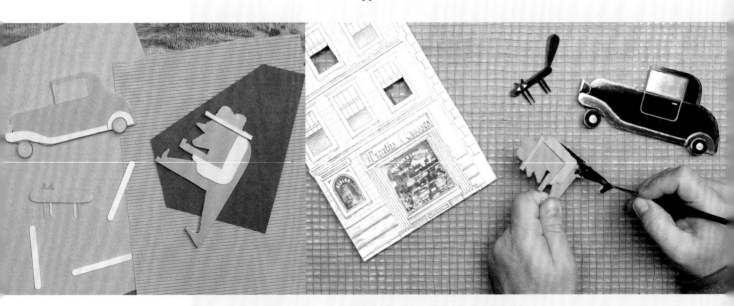

Give a highly desaturated colour (almost black and white) to the three characters using a fine pencil (No. 1) in order to give detail to the small finishes (eyes, pistol, kerchief, etc.).

[**11**] With the set already assembled, situate the different characters in the scene. Later, you'll nail them to the base (cardboard that serves as the sidewalk), supported by chopsticks that we've included in the gangster and the cat.

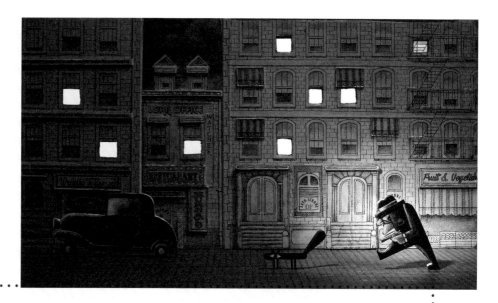

Review the illustration and outline the details that you want to retouch or enhance, making it ready for the photo shoot.

It's important to always take advantage of the variety of lighting and depth resources that photography offers us.

FOR THE PHOTO SHOOT

— The stage is finished. Now we'll assemble the photography set, placing the camera and lights the way we want and controlling the direction of the light and shadows that the different elements project. We'll take photographs with different types of lights and depth of field options, light temperatures and framing in order to be able to subsequently choose the one that we like best. It's always better to have more than less!

— This is the photograph chosen to represent the nightime scene: the light from inside the windows enhances the nocturnal atomosphere. Furthermore, in the photograph that illustrates the final double page of this chapter (the daytime scene), the windows have been digitally retouched because in this case, we didn't need the light from them.

In the last chapter of the book, you'll find simple and complete explanations of the different types of light and how to use them to achieve the desired effect (pg. 114).

You can create a story using the same characters, arranging them in the various scenes that you have illustrated. A good example of the application of this method could be a children's story. Take chances! You'll learn a lot while having fun at the same time!

And now... turn the page and see the finished illustration!

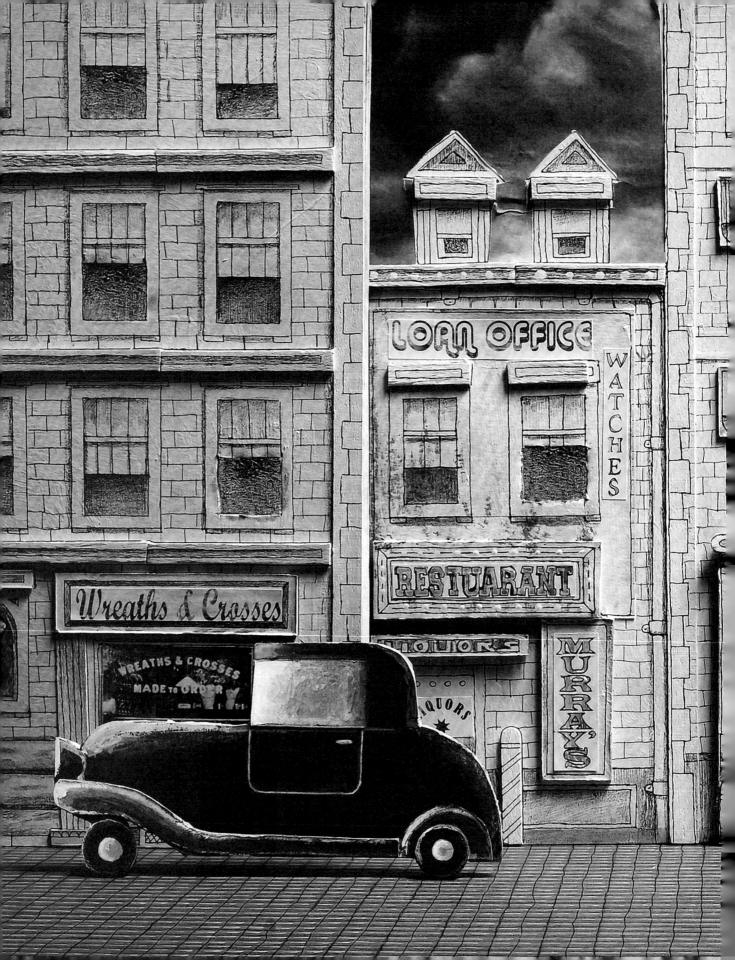

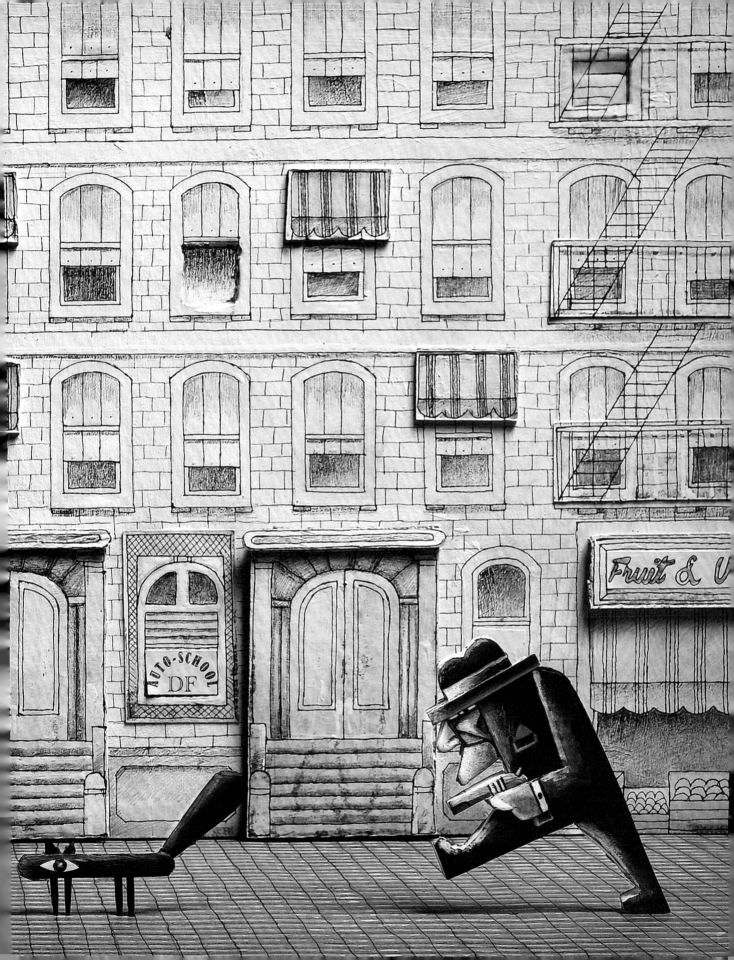

10

After exploring a broad range of techniques and materials, you've acquired sufficient skills to create with unfettered freedom.

On this OCCASION...

Anything goes!

For this new piece, we'll use a variety of materials and finishes (tissues, cardboard, found objects, nut shells, fabrics, metal, string…). The idea is to break through our own barriers without being afraid of making mistakes. All types of materials can serve our purpose! Anything goes!

MATERIALS

OBJECTIVE
To make an illustration using whatever material we have on hand. Power to imagination!

MATERIALS AND MEDIUMS

Cardboard
Compressed wood
Sackcloth
Various cloths
Peanut shells
Cellophane
Cushioned textile
 (e.g.: oven mitt)
Pencils
Screws
String
Felt
Wooden sticks
Cork
Matchbox
Metal hinges
Tissues
Gouache
Newspaper
Soda can ring
Metal rivet
Nails
Spaghetti
Photograph for
 collage
Tracing paper
Carbon paper

TOOLS

Metal ruler
Cutting mat
2B Pencil
Colour pencils
Extra fine point 0.4
 marker
Cutting blade
Scalpel
Punch
Tweezers
Hammer
Screwdriver
Sewing needle
Bitumen of Judea
Cabinet maker's wax
Rags
File
No. 1–No. 2 pencil
Thick brush
Plastic palette
White glue

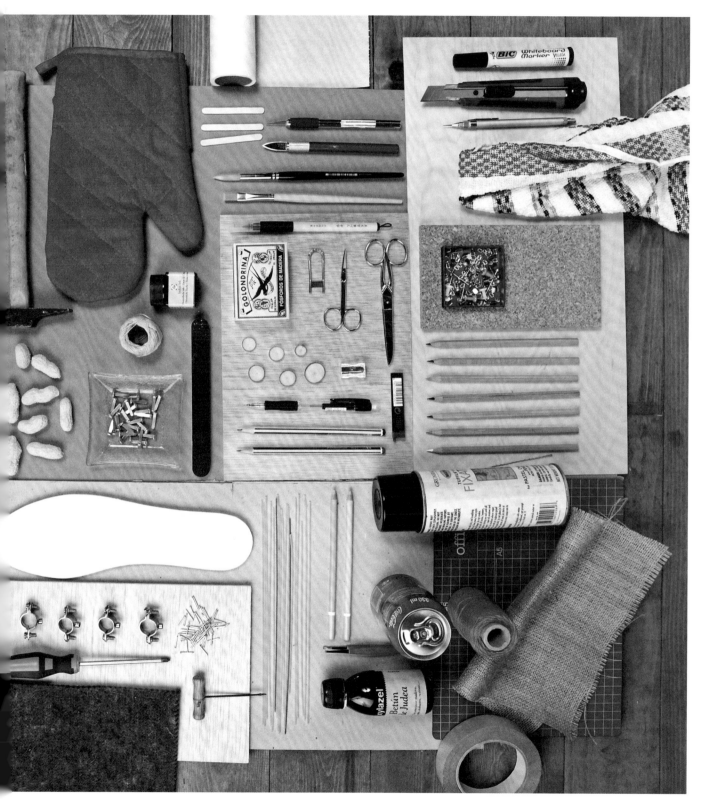

STEP BY STEP

BEFORE GETTING STARTED

Select the materials that you want to use and classify them by size, origin, type, etc. Any object that you have at home can be useful for creating an artistic image and contributing a different and original finish to your illustration.

~~~~~~~~~~~~~~~~~~~~~~~~~~~~~~~~

### *READY-MADE*, OR FOUND ART

In their desire to explore new artistic formats and languages, avant-garde artists broke new ground not only in collage technique but also through the consideration of daily objects which artists altered to give them a different perspective and new meaning. Marcel Duchamp's *Fountain* (1917) is an iconographic example of this. The found, or ready-made, object is often altered or renamed by the artist. As its original function disappears, the objects becomes something else.

~~~~~~~~~~~~~~~~~~~~~~~~~~~~~~~~

1

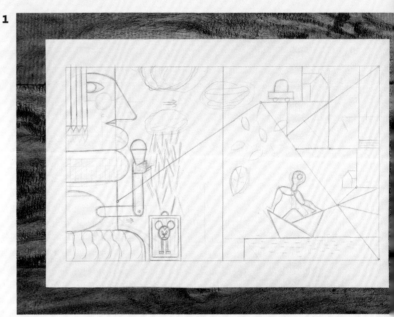

[**1**] First, as in the all the previous example, we'll draw the composition in pencil, keeping in mind the actual measurements of the final format by applying the rule of three, a simple formula for scaling the image.

[**2**] Repeat points 2, 3 and 4 of Chapter 1 (pg. 16).

[**3**] Select the materials that you want to use and classify them by size, origin, type, etc. Everything will depend how you want to combine them! Begin by selecting, preparing and placing the selected material on a 0.5 mm-thick wooden medium previously painted with white gouache or acrylic.

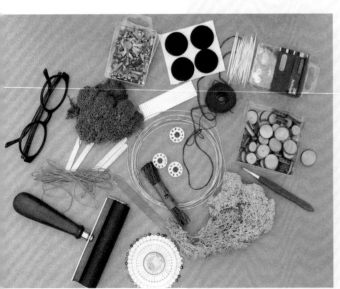

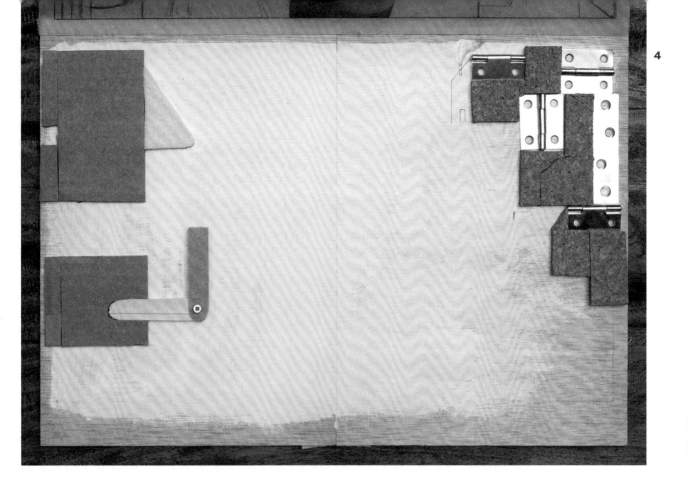

[**4**] Continue creating the image. Using the appropriate tools, freely combine the materials and apply the pieces to the wooden medium.

In this case, having a toolbox on hand is a big help.

4

STEP BY STEP

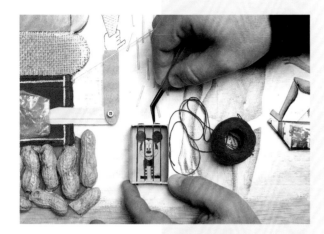

5

Experiment freely
with different materials
and mediums. It's the
best way to find your
own artistic voice! Above
all, don't hurry; assess
each action and each
combination, always
following your intuition
and your aesthetic
judgment.

[**5**] If you use metal pieces, you can give them an old and elegant look by using bitumen of Judea (as you can see in the hinges in our example illustration).

[**6**] To colour parts of the illustration, you can use the full range of artistic materials (gouache, acrylic, oil, pastel, watercolour, markers, wax, etc.), which you can find in any fine arts store. To highlight small details, you can use a pencil, marker, brush or quill.

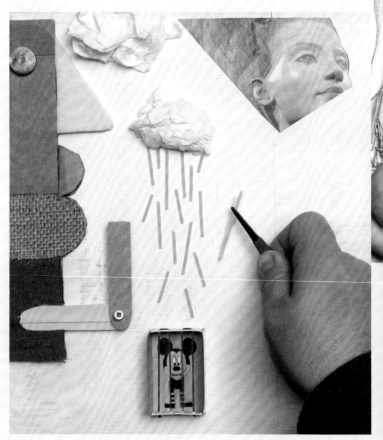

6

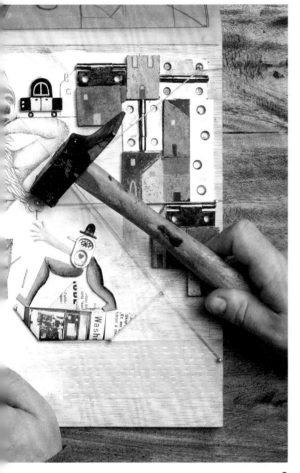

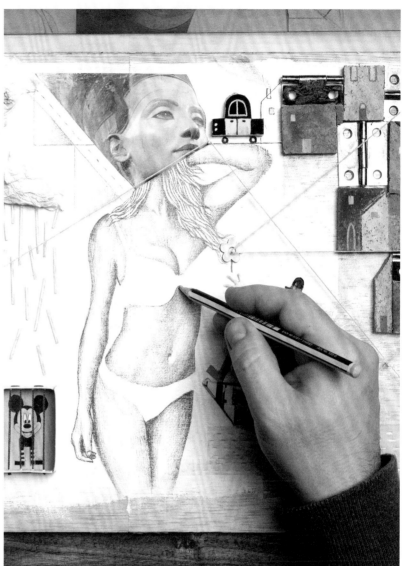

6

7

[**7**] Use a lead pencil (2B) to obtain the lines that you want to highlight, in this case, the silohouette of the girl's body.

[**8**] Apply a thin layer of fixative so that the graphite adheres well to the surface.

FOR THE PHOTO SHOOT
Use all the advantages that photography offers to grant your image the personality and tone that you wish to transmit. In the following chapter, you'll learn how to easily assemble a home photography set.

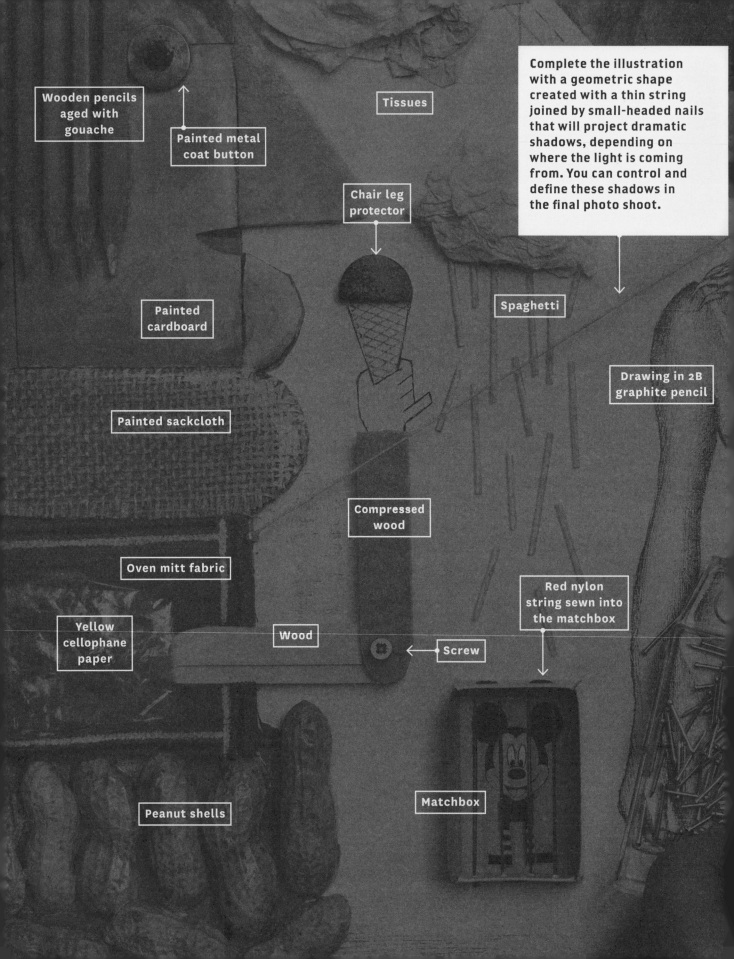

Wooden pencils aged with gouache

Painted metal coat button

Tissues

Chair leg protector

Complete the illustration with a geometric shape created with a thin string joined by small-headed nails that will project dramatic shadows, depending on where the light is coming from. You can control and define these shadows in the final photo shoot.

Painted cardboard

Spaghetti

Painted sackcloth

Drawing in 2B graphite pencil

Compressed wood

Oven mitt fabric

Red nylon string sewn into the matchbox

Yellow cellophane paper

Wood

Screw

Peanut shells

Matchbox

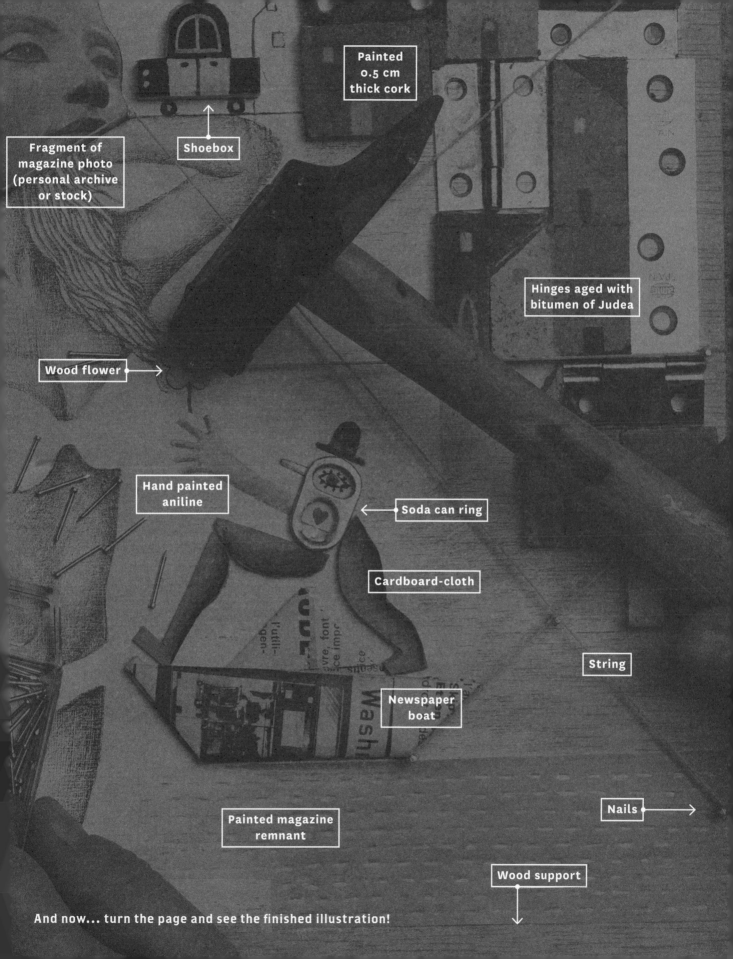

And now... turn the page and see the finished illustration!

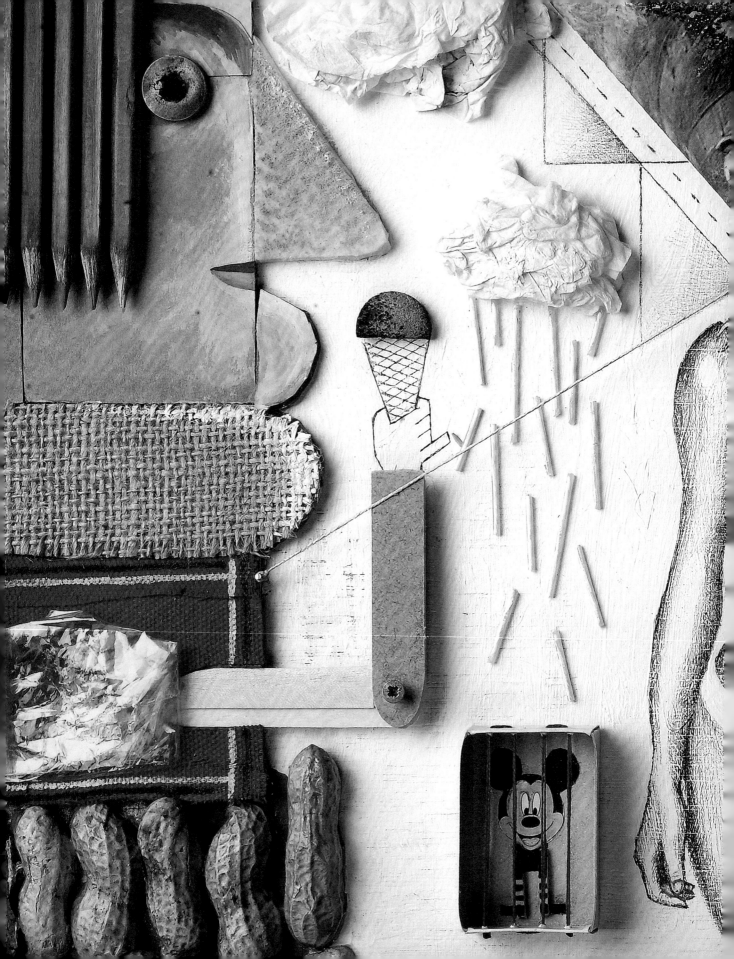

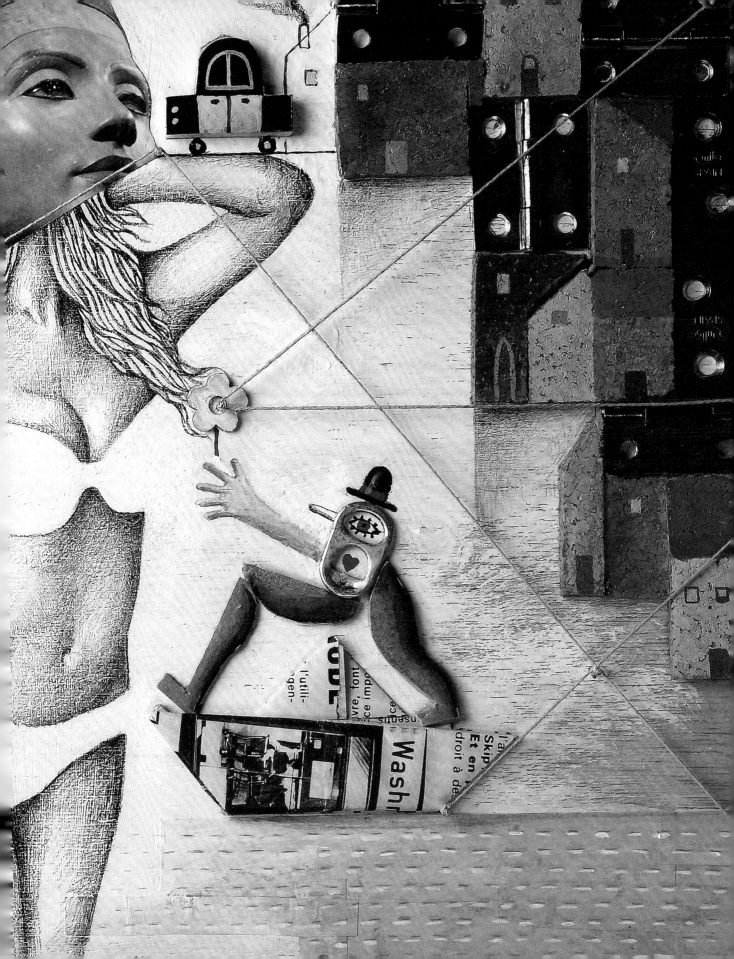

Camera and... action!

HOW TO PHOTOGRAPH AN ILLUSTRATION

Now we have our **WORK OF ART**...
And it deserves to be **PHOTOGRAPHED!**
Assuming we have a camera and are familiar
with its basic functions, we're now going to
learn how to light our illustration. Depending
on what's available, we'll focus on two types
of light: artificial light, if we have lighting
equipment, and natural light, so that you can
begin to explore this area. Following these
instructions will lead to certain success.
More than anything, you'll learn how
to observe light. Camera and... action!

ALICIA MARTORELL

We're going to the prepare the space for photography set. First, we need to determine the available light sources and prepare our materials:

MATERIALS
— Camera
— Tripod
— Wall, floor or support on which to place our illustration
— Light sources (flashes, lamps or window)
— Reflectors (mirror, white poster board, white foam board)
— Adhesive tape (masking tape)
— Blu-Tack
— The illustration

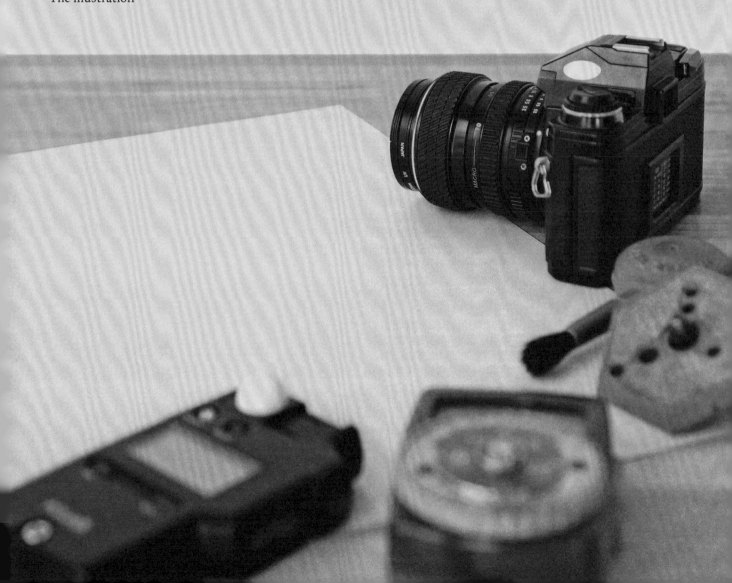

CAMERA

If possible, use a camera with a manual mode option. Depending on the available light, you will use A different ISO (film/electronic sensitivity). If there is low light, you'll need to increase the sensitivity, with the consequent increase in the grain of the image. ISO is expressed in ASA values (50, 100, 200, 400, 800, 1600, etc.). The lower the sensitivity, the more light is required, with the resulting image being cleaner.

The camera has a light meter that measures the light in the scene, which is expressed in lens aperature values and shutter speeds. The sensitive material is exposed to the light for an instant, the length of which can vary: this is called shutter speed.

Shutter speeds are expressed in fractions of a second:

— 1/1000 (one one thousandth of a second)
— 1/60 (one sixtieth of a second)
— 1/2 (half a second)
— 1 (1 second)

The less light that enters the camera, the greater the shutter speed you'll need to expose the sensitive material. The more light, the less the shutter speed. For long exposures, you'll need a tripod to help you hold the camera steady.

LENS APERTURE

The lens aperture ring is like your camera's pupil. It's represented with the letter "f" and is expressed in the following values (stops):

2.8 / 4 / 5.6 / 8 / 11 / 16 / 22

The greater the f-stop, the less light that enters the camera; the smaller the f-stop, the more light that enters the camera. An important consequence of changing lens aperture to keep in mind is depth of field, that is, the amount of area in focus in the image. The greater the f-stop, the greater the depth of field we obtain, that is, more area in focus; conversely, a lower f-stop, results in less area of the image in focus.

These factors need to be kept in mind when deciding what type of lighting you want or have for photographing your illustration and what kind of photographic results you're looking for.

DEPTH OF FIELD

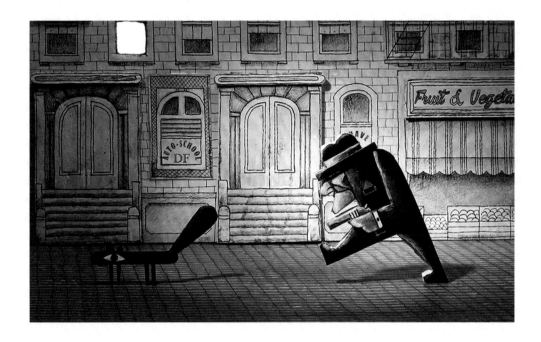

SPECIFICATIONS
f 16
Shutter speed. 1/60
ISO 125
Lighting with studio flash

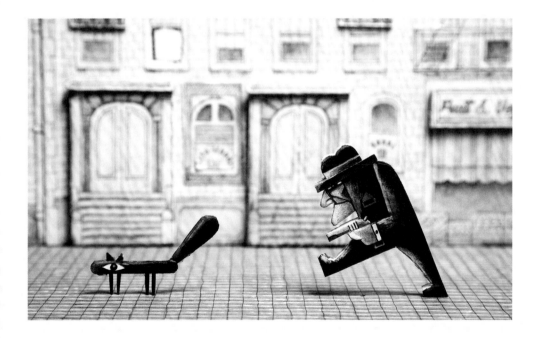

SPECIFICATIONS
f 6 (f 5.6 1/3)
Shutter speed. 1/60
ISO 125
Lighting with studio flash

WHAT KIND OF LIGHT SOURCE DO WE HAVE?

FLASHES AND LAMPS

Ideally, you want to work with studio flashes. However, often we don't have them, unless we're photogaphers or have a photographer friend who will lend them to us, and even then we need to know how to use them. The advantage of studio flashes is that they emit a large flash of light that allows for comfortably photographing the scene and controlling the intensity of the required flash. In addition, the light they emit is calibrated like the colour temperature of the sun at noon, around 5,500K (Kelvin degrees), which is the whitest light that exists. In this way, we eliminate the risk of dominant colours in our final image. Lamps are used with a variety of accessories to manipulate the harshness or softness of light in numerous forms.

LIGHTING WITH HOUSEHOLD MATERIALS

60W or 100W incandescent bulbs, which are the brightest ones that tend to be used in the home, do not produce a sufficient amount of light for taking a good photograph. Halogen lamps, however, which have a similar light temperature but are much stronger, will allow you to take a quicker image. Two 500W lamps, like the one we used to paint walls, will prove very useful to you. Keep in mind that halogen light is yellow, that is, it has less Kelvin degrees than a flash (between 24000 and 30000 K): you'll need to adjust the balance of whites in the camera to tungsten light (it's indicated with a bulb).

Another important thing to keep in mind is that the harshness of the light is proportional to the size of the object that needs to be lit. If we're lighting something big, the resulting light will be harsh; that is, it will create heavy shadows. On the other hand, if the illuminated subject is small in relation to the light source, the light will be soft, enveloping the object and creating smooth transition between areas of light and shadows. To soften the lighting, we can place a piece of carbon paper in front of the lamps or bounce the light off white walls or white posterboard, taking care not to burn anything, as the light that is being emitted remains hot.

THE MOST ECONOMIC OPTION: SUNLIGHT!

To obtain the maximum advantages of daylight, you need to observe the quality of the available sunlight at the time. If we're inside, we'll work with the light entering through the window. If the light is indirect, the illumination will be soft. If that's the light we need, perfect. We can also work outside using direct sunlight. In that case, we'll need to keep a few things in mind. First, you need to be aware of the time of day. In the early morning and late afternoon, the colour temperature of the light will be lower and the light more yellow. At noon, the sunlight is white (like studio flashes). If it's cloudy, the colour temperature rises and the light is slightly bluer.

We'll also decide on the quality of the light, if want soft or harsh light. If we're looking to create contrast, direct sunlight is the harshest light there is and shadows will be highly contrasted. On the other hand, if we want soft light, we'll need to work on a cloudy day, as the clouds will disperse the rays of the sun, resulting in soft, diffuse shadows. Still, we need to control the balance of whites in the camera to counteract the dominant blue that this light gives us.

We don't recommend working with natural light when the day is variably cloudy, for this constantly affects the amount and temperature of the light and requires that we constantly monitor whites, speed, the lens, etc.

Finally, we need to keep in mind the objects that are close to our scene. Ideally, we want them to be neutral colours in order to avoid colour contamination in the object we are going to photograph. Avoid large colourful walls or surfaces close by.

REFLECTING AND BOUNCING LIGHT

In any of the three lighting situations (studio flashes, tungsten lamps or daylight), we can take advantage of elements that bounce the available light. Reflectors (white poster board, white foam board, mirrors, etc.) will help soften unwanted shadows and brighten areas that are a bit too dark. The important thing is to observe what we have before us and what happens with the light. In the following examples, we'll see that, depending on how we use light, one or another atmosphere is created.

PRACTICAL EXAMPLES

The formulas provided below apply to light from studio flashes and continuous lighting lamps (such as the halogen lamps we mentioned above), keeping in mind that:

1) The amount of light is less in continuous lighting; consequently, we need to adjust the exposure values accordingly.

2) The sharpness and cleanliness of the image will be considerably less. The higher the ISO/ASA, the larger the grain in the resulting image.

EXAMPLE 1

HOW TO HIGHLIGHT SHADOWS WITH DIFFUSE LIGHT

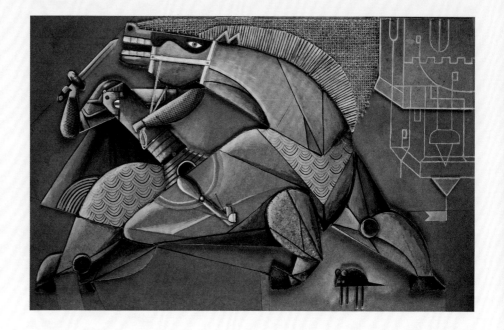

SPECIFICATIONS
f13 (f11 1/3)
Shutter speed 1/60
ISO 125
Lighting with studio flash

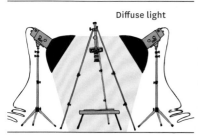

Lighting with flash

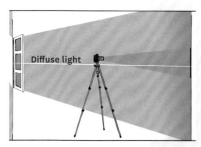

Lighting with natural light

LIGHTING WITH FLASH

In this version, we used 2 light sources, 2 studio flashes with a light box, which produces diffuse light that works well if what we are photographing is flat. To obtain diffuse light with continuous lighting lamps, we can use tracing paper to diffuse the light, taking care not to burn the paper. Alternatively, we can bounce the light off of walls or white surfaces. The two lights are at the same angle and produce the same quality and quantity of light to illuminate the scene without shadows. Since the illustration has volume, soft double shadows appear (in the two directions), each produced by a lamp. The image is well lit, but the type of illumination makes it very flat and the double shadow is visually unpleasant.

LIGHTING WITH NATURAL LIGHT

If you don't have lamps or studio flashes, you can use available window light. As this type of light cannot be moved, you'll have to move your illustration. If you want very flat and diffuse light, place the illustration on the wall opposite the window. The light will hit the illustration perpendicularly and produce very small shadows. Place the camera between the window and the illustration. The window will not produce double shadows.

EXAMPLE 2

HOW TO
HIGHLIGHT
VOLUMES

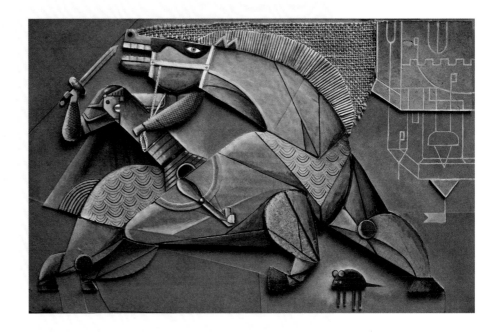

SPECIFICATIONS
f10 (f8 2/3)
Shutter speed 1/60
ISO 125
Lighting with studio flash

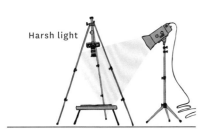

Harsh light

Lighting with flash

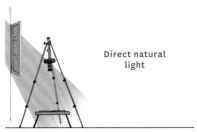

Direct natural light

Lighting with natural light

LIGHTING WITH FLASH

This time, we used a single light source to highlight the volume of the illustration. Here the light comes from a high point: the shadow cast by the volumes in the illustration is very small and intense, since we didn't use a diffuser. The contrast is strong and the lower part of the illustration receives less light. The direction of the light can be seen very clearly.

LIGHTING WITH NATURAL LIGHT

In order for the window light to produce rather intense lateral light, we'll need to do the shoot on a sunny day with the sunlight entering directly through the window. If possible, don't photograph the object at noon, when the sun is at its zenith, which would result in a small amount of lateral light. Then – as always – we'll have to adjust the balance of whites. Ideally, the whites should be adjusted manually for each lighting condition under which we plan to photograph. To do this, place a white sheet above your illustration, locate the white balance in your camera settings, select manual mode and focus the camera on the paper, filling the frame. The camera will have read and calibrated the light striking the paper at this time, eliminating any dominant light in the lighting situation. Doing this will ensure a proper exposure for your photographs.

EXAMPLE 3

HOW TO HIGHLIGHT SHADOWS IN ONE DIRECTION

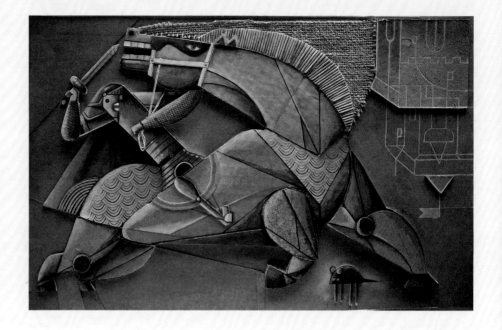

SPECIFICATIONS
f7 (f5,6 2/3)
Shutter speed 1/60
ISO 125
Lighting with studio flash

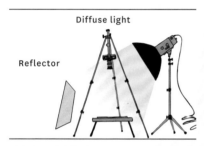

Lighting with flash

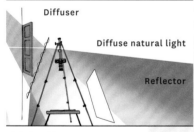

Lightig with natural light

LIGHTING WITH FLASH

In the above image, the shadow cast was very dense and short, only slightly detached from the volumes of the object, as the light was very perpendicular and we didn't use diffusers. How can we prevent this? If we move the light from side to side and up and down, we see what happens with the shadow: it also moves. We now need to determine where want the shadow and which features of the illustration we want to highlight. In this case, to pull the horse out from the background, we can lower the lamp or flash so that the light strikes the object more laterally. As a result, the shadow increases, though ultimately we'll want to soften it for a harmonious result.

We've added diffusers to the light source to soften the intensity of the shadow and its outlines, in addition to a white reflector that bounces the main light, with the aim of filling in the part of the illustration that receives the least amount of light.

LIGHTING WITH NATURAL LIGHT

In the case of natural light, situate yourself next to a window where the sunlight is not very direct and move the illustration close to it to observe how the shadow cast appears. If the shadow is very dense, place a piece of muslin or a diffuser between the window and the illustration that will considerably soften the shadow. Likewise, you can bounce the window light with white cardboard from the area opposite the light to fill in the less illuminated area of the illustration. The resulting image may work. Still, because of the expressiveness of the illustration and the tension inherent in the scene involving the main characters, we suggest accentuating this drama.

EXAMPLE 4

HOW TO CREATE DRAMA IN FIGURES

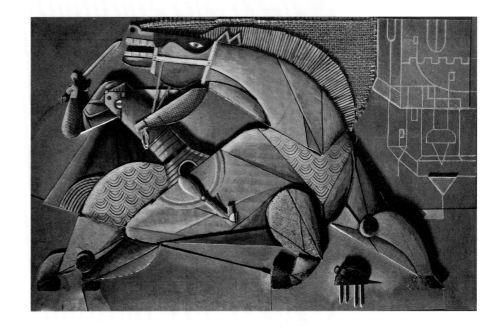

SPECIFICATIONS
f14 (f11 1/3)
Shutter speed 1/60
ISO 125
Lighting with studio flash

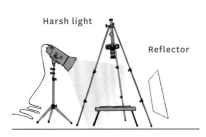

Lighting with flash

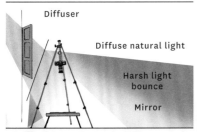

Lighting with natural light

LIGHTING WITH FLASH

To add more drama to the illustration, accentuating the expressions of the main characters and intensifying the tension in their figures and faces, we can drastically change the direction of light and harshen it so that the shadows that are cast come from below are contrasted and dense. To do this, we'll place the lamp on the lower side of the illustration, in a very low position in order to increase the size of the shadow cast. To prevent the upper part from being too dark, we'll bounce the light off of white cardboard.

LIGHTING WITH NATURAL LIGHT

If we don't have lamps and are photographing with the help of natural light, we can use mirrors to intensify the drama of the scene.

The mirror is placed in the light, in the lower part of the illustration, slightly higher than the plane supporting the object and close to the window. We then move the mirror until we find the correct angle for illuminating our illustration, casting the desired shadows.

With these pointers, you can begin your own tests and experiments. Discover the expressive potential of your work. At the end of the day, it involves nothing more and nothing less than knowing how to control light!

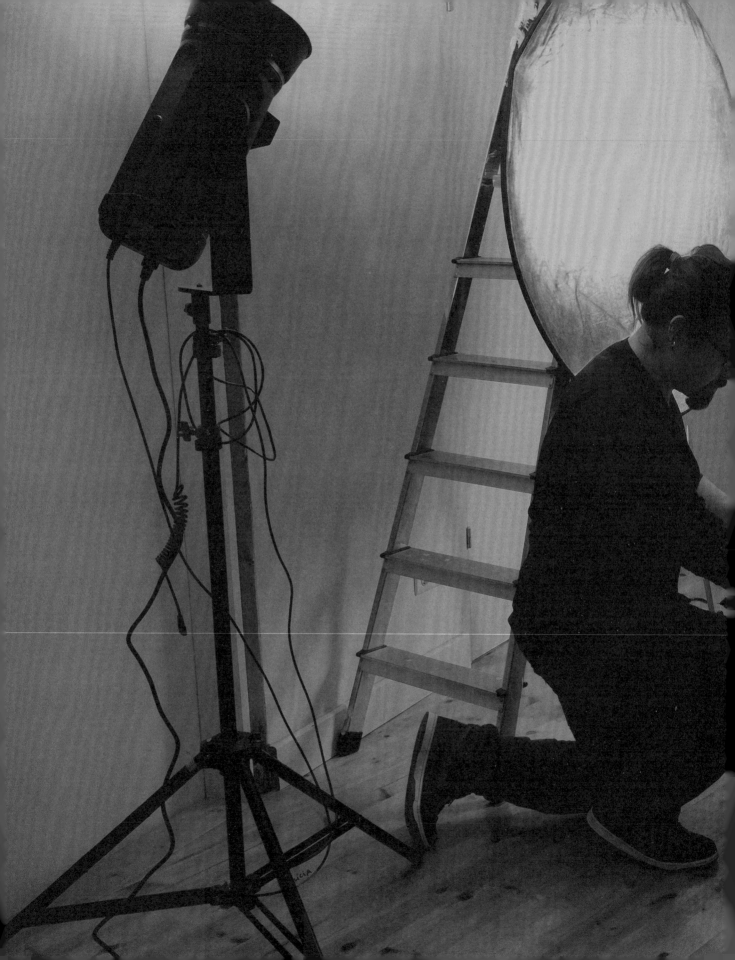

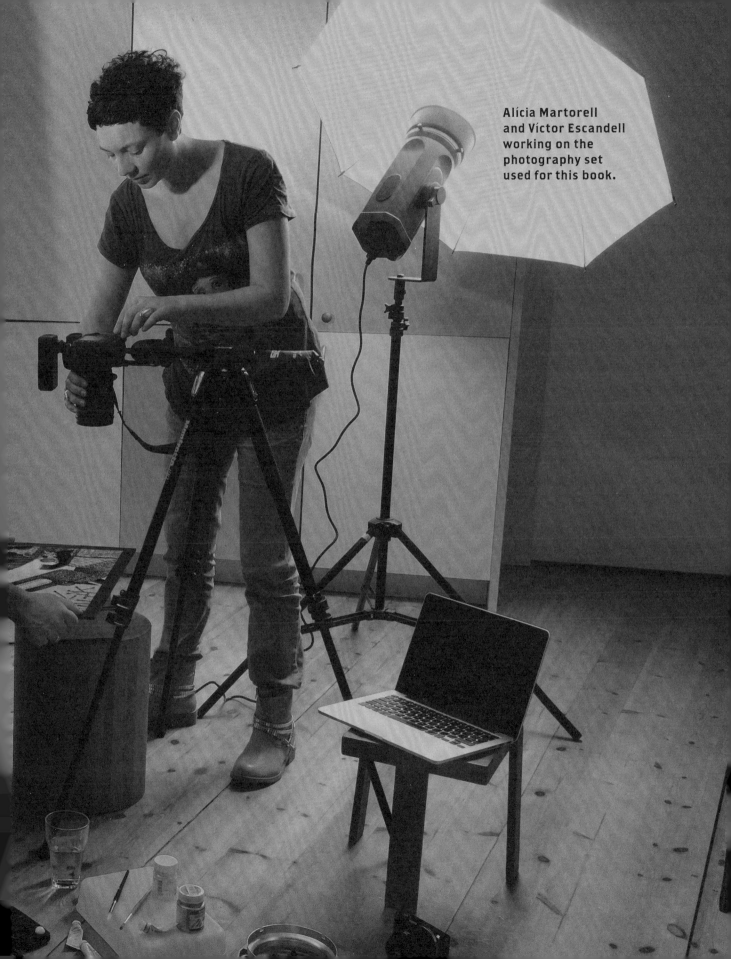

Alícia Martorell
and Víctor Escandell
working on the
photography set
used for this book.

Víctor Escandell in his studio.

VÍCTOR ESCANDELL was born in Ibiza, in 1971, and began his professional career as an illustrator in 1989, creating storyboards for an animated film production company in Barcelona. Since then, he has illustrated news articles on a regular basis for such Spanish newspapers as *El País*, *El Mundo* and *El Periódico de Catalunya*, among others. In 1998, he founded Alehop, a studio that provides graphic design and illustration services, collaborating with major advertising agencies illustrating print and television campaigns at the national and international level. He has published a number of illustrated books, both for children and adults, and, thanks to his versatile style, also works together as an illustrator with organisations and companies in a variety of sectors. His work has been awarded with such prizes as the Junceda, Anuaria, Daniel Gil and ÑH05 de Diseño Periodístico for newspaper design, to name a few.

A selection of professional works that Víctor Escandell has produced using the mixed media and collage techniques developed in this book.

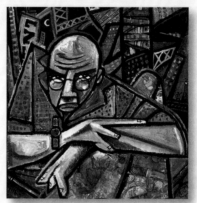

Illustration created for new article in *El Periódico de Catalunya* (2004).

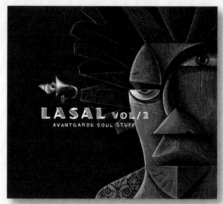

Illustration created for cover of CD *LASAL vol/2 AVANTGARDE SOUL STUFF* (2006).

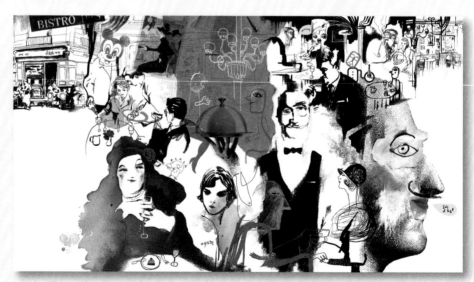

Interior illustration created for the book *Déjà vu*, published by La Galera (2012).

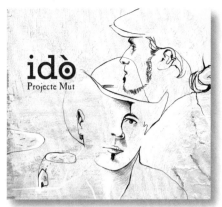

Illustration and design for cover of the CD
IDÒ by band Projecte Mut (2014).

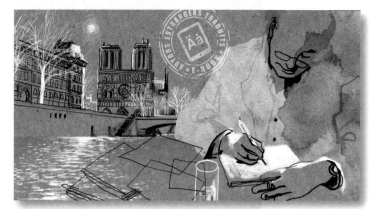

Illustration created for news article in *El País* (2014).

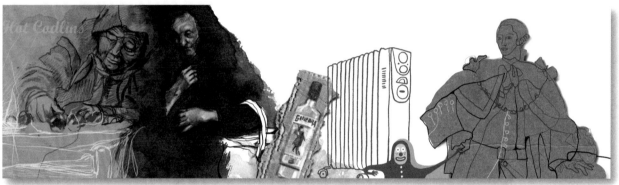

Fragment of illustration created for animated video about clown Joseph Grimaldi, broadcast on TV3,
Televisió de Catalunya (2014).

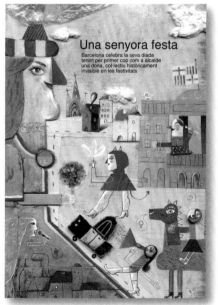

Illustration for the cover of *El País* (2015)
newspaper supplement.

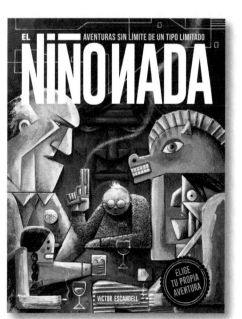

Illustration created for the cover of the book
El Niño Nada, published by Bang Ediciones (2016).

"The world is full of small joys:
 the art consist of telling them apart"
LI-TAI-PO